Tim Daly

The Digital Printing Handbook

A photographer's guide to creative printing techniques

argentum

Tim Daly

The Digital Printing Handbook

A photographer's guide to creative printing techniques

Contents

Why Digital Printing?

Photographers have relied on silver-based print materials for over 160 years. Digital printing offers all the hands-on control of the conventional craft darkroom processes, plus more.

The rapid technological advances in digital photography over the last five years has given rise to a new kind of image making. Digital printing has emerged as the most exciting development since the birth of photography itself liberating image makers from many previously restrictive limitations. Forged from a mix of science, fine art, darkroom craft and reprographics, digital printing offers precise control at every stage of the creative process. Yet with so many variables and so many techniques to use, there's ample room for error and disappointment.

Armed with a good-quality inkjet printer, a computer and the right software, you can exercise all your creative talents on a wide variety of different papers thick and thin, big and small, and venture into previously unimaginable fields of experimentation.

The Digital Printing Handbook is designed as a reference guide for keeping maximum quality throughout each stage of input, creative manipulation and final output processes. With easy-to-follow recipes for colour and monochrome effects, this book will enable you to make great-quality prints from your own digital images, without the expense of mistakes.

All software-driven creative processes attract users with a wide range of expertise and this book aims to bridge the gaps in your knowledge. If you have a background in traditional darkroom printing, then you are already well placed to take advantage of new digital printing techniques. Good at making instant creative judgements, your downfall is likely to be the overwhelming technical jargon concerning bits and bytes and other core elements of digital theory. Yet if you are coming from an IT background, then the more unfamiliar type of decision making, using your subjective and creative judgement, is outlined here too.

Perhaps the most discouraging part of learning a new skill is the lengthy and protracted routes caused by inexperience. Watching and taking note of professional practitioners will help you to find fast and intuitive ways to make pictures, without labouring for hours in front of your computer.

With plenty of practice and experimentation, you will start to drive the software and hardware at your own speed rather than being driven. Like a complex camera, with programme modes for every situation, there are large parts of Adobe Photoshop that you will never need to use.

The keynote to this book runs parallel to the best way of learning conventional photography: understand how it works manually before you use the gadgets. All essential background is supported by useful techniques that will not become redundant with software updates.

Web links

Many of the recipes and techniques used in this book have also been made into downloadable Photoshop files, available from the author's own web site. If you are a Photoshop user, these files can be used to customise your own workstation, allowing you to add yet another useful set of tools to this enormous application.

Most precise controls for colour and tone effects or even a lengthy process can be saved as image independent files and applied to new images, without the need for repeating yourself.

Many readers will want to share their own specialised processes with others and the author encourages users to contribute Action files, duotone recipes and any other useful information to the Photocollege community.

Visit the site at **www.photocollege.co.uk** for more information.

Chapter 1

COMPUTER HARDWARE

⋯⋯⟩ The workstation

⋯⋯⟩ Storing your work

⋯⋯⟩ Digital output devices

⋯⋯⟩ How inkjet printers work

The computer workstation

The fastest computer in the world won't make your prints any more interesting to look at, but it's important to understand how it works.

For creative people, the detailed description of a computer's innermost parts is irrelevant. Yet as a sound technical understanding of cameras and sensitive materials underpins the best photographers, so a basic grasp of a computer's innards will enable you to make an informed choice when purchasing equipment for the first time. Buying the right computer hardware is no more complicated than buying compatible lenses for your existing camera system. Digital imaging technology has now reached a reassuring plateau with bottom-of-the-range machines being perfectly adequate for scanning, manipulating and printing photo-quality images. There's less danger now of buying a white elephant, so your choice rests on two factors: how fast you want to work and your budget.

Apple or IBM PC

Apple computers are designed for creative professionals and are at the forefront of many leading technological innovations. PCs running Microsoft Windows are aimed at the home business market. So what's the difference? Apple computers have a rigorous set of internal design rules, so all third-party companies making printers and scanners are forced to comply with these clearly defined rules. Windows PCs however, are constructed by many companies from lots of different internal

bits. Adding compatible memory, scanners or printers to a PC can be potentially baffling for a new user and unfortunately there's often no way of foreseeing a problem until it arises. If you are concerned about swapping between the two platforms, having a PC at work and a Mac at home, you can easily read the same files on both systems, providing you stick to a few basic rules. If you are new to digital imaging and want to keep your involvement with technology to a minimum, i.e. switching it on and getting on with the creative stuff, then an Apple is easily the best choice. If you still feel strongly about using a PC, opt for a recognised make such as IBM, Dell or, if you've got a bigger budget, consider a Silicon Graphics workstation.

Speed

Digital images are data heavy, requiring long and complex sets of instructions to recreate them. Each time an image document is manipulated, be it a simple rotation or a more complex filtering, this data needs to be updated to reflect the changes made. An efficient computer therefore is essential if you don't want to sit around waiting for a task to finish.

Processor

The processor is the engine of your computer, the speed of which is described

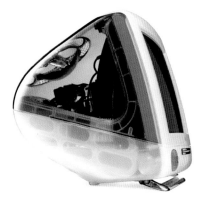

All-in-one computers and monitors like the iMac offer a cost-effective and space-saving way into digital photography. With a high-resolution display and enough VRAM to display millions of colours, the iMac is a good starting point. ▼

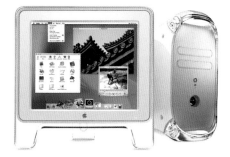

More powerful desktop computers like the Apple G4 are purpose built for professional graphics work. Apple processors are specially 'tuned' to run Adobe Photoshop at lightning speed.

▲

Once a black-market commodity, RAM chips have fallen dramatically in price. It's essential to install as much RAM as you can afford. Installing extra RAM is a very simple procedure.

in megahertz (MHz), with 1MHz describing one million calculations per second. Current computers use processors ranging in speed from 450Mhz to 1.2Ghz. Don't be fooled into thinking that Mhz is the sole determinant of speed; it isn't. Mac computers use G4 processors and Windows PCs use Pentium or AMD chips. Although on inspection Mac processors appear to be rated at lesser speeds than Pentiums, they are in fact designed to work faster using specific applications like Adobe Photoshop. If Mhz is like your car's engine capacity, think of a Mac processor like a fuel-injection model. Dual processor models, as their name suggests, have two engines rather than one and make light work of large image files.

RAM

Random Access Memory is the part of a computer which keeps all the active applications and documents up and running. This includes the operating system, such as Windows 2000 or Mac OSX, your imaging application, like Photoshop, and your open image files. All data held in RAM is lost when your computer is switched off, or when it crashes, so it's important to save it to disk first. RAM is not represented on your desktop like a hard drive, but can be configured to meet your precise requirements. It's essential to install as much RAM you can afford, with 128Mb a good starting point, but if you can stretch to 256Mb or more, you'll really notice the difference. If your machine has limited RAM, once this has reached capacity, virtual memory will be switched on by writing data to the slower hard drive. Look for a computer which has three vacant slots for adding extra RAM later on.

Operating systems

Windows 95, 98, 2000, Mac OS 9 and Unix are all different types of operating system software. The job of your OS is to communicate with your computer hardware, a bit like the human nervous system sending out signals. Operating systems are continually being improved by manufacturers keen to offer their users a more intuitive and useful experience. Most peripherals are designed only to work with particular versions of an operating system.

VRAM and graphics cards

The visual display of high-quality images on your monitor is drawn from a palette of millions of colours and needs a special kind of memory chip called VRAM. To display very high-resolution images on large monitors such as 21-inch, you might need to replace your VRAM chip with a better one. New computers are supplied with a minimum of 8Mb VRAM and many have 16Mb for a faster refreshing display.

Bus

A bus is a computer's internal system of wiring, used to carry instructions back and forth at great speed. Bus speed is the rate at which data can move around. It will also have an effect on the performance of your workstation.

Hard disk or drive

A computer's hard disk is used for storing all less urgent data such as unopened documents and unused applications. Hard drives nowadays are produced in large capacities measured in gigabytes, such as 30Gb, and are also produced to spin at different speeds such as 7200rpm. Quick-spinning disks permit faster saving of data together with the type of connecting cables used for transfer. As the storage of image files can take place on external media such as CDR disks, it's less crucial to have the biggest hard drive. Many computers are designed with a vacant internal space, called an expansion bay, for adding a second or even third hard drive.

PCI slots

Personal computer interface slots are vacant bays for adding extras to improve your computer's specification or performance. Modems, graphics cards and SCSI cards are easily inserted into a connecting channel. Most good computers will have at least three PCI slots.

Ports

Connecting your computer to a peripheral device like a scanner or printer occurs through a special type of socket called a port. Like all other components, ports have been developed over the years to allow faster transfer of increasingly larger volumes of data. Parallel, Serial, SCSI, USB and Firewire are all different types of connector used by peripheral devices and must be plugged into a corresponding socket in the back of your computer. Check that you have the right port before buying a new peripheral device, and if you haven't, check out the price for an upgrade card.

Buying your workstation

By far the best way to buy is to shop online. With low overheads, online resellers frequently beat high-street best prices and carry larger stocks. At the start of a new computer range, look out for discounted prices on last season's models. Like commodities on the stock market, the price of RAM can fluctuate widely, so take advantage of any drop in price to upgrade your machine.

Limited budget

If you don't have a fortune to spend on a new workstation, put your money into a computer with an entry speed processor and spend the surplus on extra RAM and a good monitor. Don't be fooled into buying bundles, unless all parts of the kit meet your requirements exactly. All-in-one workstations like the iMac offer good value for money for a beginner, albeit at the expense of a smaller monitor.

Upgrading older computers

If you are confident about wiring a plug, then you will have no problem in adding extra memory, a SCSI card or even a bigger hard disk. The market for third-party upgrades is very competitively priced and most products can be easily installed with screws and plugs rather than a soldering iron. By following precautions against static electrical discharge, there's little damage you can do. Without needing to upgrade your processor, a costly business, extra memory and a faster-spinning hard drive will dramatically improve the performance of an elderly system.

Monitors

Human eyes are high resolution and can sense an enormous range of different colours and tones. A computer monitor however, has many more limitations. Inside the plastic shell is a cathode ray tube (CRT), the inner surface of which is coated with phosphors at the flattened out end (the bit you look at), which glows and produces light when hit by an electron beam. A monitor is the most important piece of equipment and you need to be confident that your monitor is good quality and gives you nothing but the truth. Phosphors don't perform indefinitely and accurate colour calibration may be impossible on elderly monitors, so don't be tempted to buy second hand.

Large monitors are best for imaging as Photoshop has many palettes which take up a lot of desktop, leaving little space for your image window. Seventeen-inch monitors are a minimum, but for a couple of hundred pounds more, you can invest in a 19-inch model. Most new computers are sold with a minimum 8 megabytes of video RAM, easily enough to run a large monitor with millions of colours. Monitors for quality imaging work should be used with a colour display of never less than thousands of colours and most preferably millions. On the latest Apple computers, it is possible to add a second, smaller monitor of lower quality, to display Photoshop's palettes, leaving the bigger monitor to display a full screen image. Buy the largest you can afford and keep to respected manufacturers such Sony, Apple, Mitsubishi or La Cie.

The sharpness of the image created on the monitor depends on a kind of internal stencil screen called a shadow mask. This is a thin sheet of metal with minute perforations, which help to direct the electrons to the phosphors. Trinitron tubes, found in Sony and many Apple monitors have a unique shadow mask based on fine wires, which create a sharper display image. The term dot pitch describes the distance between the perforations on the monitor's shadow mask: the smaller the number the sharper the image will be. Better displays usually have a dot pitch under 0.28mm.

Monitors have a much smaller dynamic range than prints or film and are not able to display the deepest shadow tones or special printer's ink colours. The image you see on the monitor screen will never equal the printed version and it is wise to accept this fact before starting.

Flat-panel monitors are the latest development and many use a new screen technology called Thin Film Transistor (TFT), delivering better colours than older LCD screens. Taking up much less desk space and costing roughly five times more than conventional CRTs, the Apple 15-inch TFT is about £1000 with the gigantic 22-inch Apple Cinema display priced around £2500.

Storing your work

Saving multiple variations of an image can take up huge amounts of space, so keep an unmanipulated 'original' to interpret as you would in the darkroom. Like a precious negative, pay equal attention to storing your data on stable and uncorruptible media.

Although today's computers are supplied with gigantic hard drives, there are advantages to storing your images on removable media. Hard-drive space is frequently used as overflow RAM, called Virtual Memory, but only if such space exists in the first place. Your computer will grind to a halt if you only have a tiny quantity of free hard-drive space. High-capacity storage media like CDR, is good value for money and, accompanied by a printed index cover, can give you a much more visible storage system. A computer with a built-in CD writer is a good option for a new user.

Backing up

An alternative to storing images externally is to use a back-up device and software. Unlike writing your data to disks, backing up can occur invisibly, at any time of day or night, so you don't have to think about it. There are lots of different kinds of back-up drives available with software like Retrospect that do all the work for you. Attaching an external hard drive, DLT or DAT tape drive to your computer can give you an additional 70Gb of data storage. Tape drives tend to have a slower data-transfer rate and will be noticeably slower when retrieving data.

Additional hard drives

Most computers are supplied with a vacant space to install one or more additional hard drives, up to 60Gb size with current products. At a much lower cost per megabyte than all external back-up drives or removable media, an additional hard drive could be reserved for your image storage and so not interfere with Virtual Memory functions. Installation of an additional drive is a straightforward procedure, using connectors already present in your computer's vacant drive bays. You could also install extra drives into an older computer to act as a server.

Media type	Capacity	Number of 24 Mb RGB files	Device required	Reusable	Value for money
3.5-inch floppy disk	1.4 Mb	0	Standard built in disk drive	Yes	0/10
100 Mb Zip disk	96+ Mb	3–4	External or internal Zip drive	Yes	1/10
250 Mb Zip disk	240+ Mb	9–10	External or internal Zip drive	Yes	3/10
650 Mb CDR	650 Mb	25	Needs CD Writer	No	9/10
650 Mb CDRW	650 Mb	25	As above	Yes	7/10
1 Gb Jazz cartridge	1 Gb	40–41	External SCSI Jazz drive	Yes	4/10
2 Gb Jazz cartridge	2 Gb	80+	External SCSI Jazz drive	Yes	5/10
3.9 Gb DVD-R	3.9 Gb	150+	Needs DV writer	No	5/10
5.2 Gb DVD-RAM	5.2 Gb	200+	As above	Yes	7/10

Digital output devices

There's an enormous range of printers on the market, but which one will let you create the results you're after?

At a low cost and aimed solely at the domestic and office market, the basic inkjet printer comes armed with four standard CMYK colours. Print results are perfectly acceptable for solid graphic and text output, but this kind of device lacks the ability to reproduce the delicate tonal and colour gradations found in a photographic image. With a four colour cartridge, print-outs with flesh tones and white highlight areas will display the tell-tale signs of visible inkjet dots. Driver software will contain mainly preset options, rather than full-on manual controls.

Photo-realistic inkjets

Defined by the word photo in the product description, a much better option is the photo-realistic printer. At about twice the price of a domestic inkjet, this device will have more sophisticated software and be able to print onto a wide range of different paper surfaces and up to A3-sized output. These inkjets use the four standard CMYK colours, plus two extra ones: light cyan and light magenta to emulate the subtleties of photographic colour. For a slightly higher cost, opt for a printer which uses lightfast inks, such as an Epson Stylus Photo with 'Intellidge' ink cartridges. With the right combination of paper and ink, this will give you the highest-quality output and is an excellent first-time buy.

Professional inkjets

At about three times the cost of a photo-realistic printer, this kind of device is aimed at the professional photographer market. Dropping ink at the highest resolutions such as 1440 and 2880, professional inkjets are designed to output prints for commercial end use. To avoid the problems associated with fading, these printers use a pigment-based ink, rather than cheaper dye-based inks. As such, consumable costs are considerably higher with this type of device. Better colour-management software should be provided. Unfortunately you can't refill or buy single ink-colour cartridges, so making a predominantly blue print might use up your entire blue ink in one print!

Wide-format inkjet

Aimed at the graphics and lab trade, wide-format printers use exactly the same mechanism as desktop machines, but with a much wider carriage. Print widths are up to 44 inches (and over) and are combined with a roller paper feeder, lengths are unlimited. Print media include weatherproof vinyl, canvas, and card for point of sale and trade exhibition display. With minimal production costs and no penalties for short-run jobs, wide-format printing has taken a market share away from the commercial silkscreen service.

Print resolutions for these devices need not be high, due to the greater viewing distances involved when looking at large-scale images, leaving the viewer's eye to optically merge the dots. Ink cartridges are usually separate and refillable, so there's no danger of running out mid-job. Better machines are supplied with industry standard Postscript Raster Image Processing (RIP) software, or (a better bet) hardware RIP acting as a processor and print server. You need to have a fast network to cope with sending large data files to print such as 100Tbase, and big pieces should be left overnight to print out.

Dye-sublimation

Ten years ago, the dye-sublimation printer was the only quality device for digital printing. Dye-subs produce a continuous tone image, with little evidence of pixellation, provided the image file is prepared at the right resolution, ie 300dpi. Compared to the output resolution needed for a photo-realistic inkjet, image data files will need to be at least 50% larger. Dye-subs use four colours: Cyan, Magenta, Yellow and Black and work by fusing dye into specially manufactured transfer paper. The receiving paper is pulled four times through the printer making a separate impression with each colour. This can give problems with registration, and if dust or fibres get in between passes, there'll be a very visible glitch. Consumables cost is very high, especially the dye ribbon, with

Four-colour inkjets are aimed at the home and small office market. Printer resolution and software is designed to achieve near-photographic quality results for report-type documents.

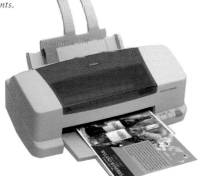

Professional inkjet printers such as the Epson 2000P have been designed with the professional photographer in mind. With lightfast pigment-based inks, albeit with a smaller colour gamut than dye-based inks, this kind of device makes prints that will last.

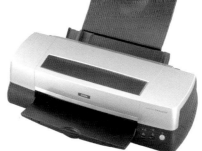

Large-format output devices are aimed at professional labs and graphics companies. With the ability to print onto a wide range of paper, plastic and fabric media, including weatherproof material, this device has become the cost-effective choice for large-scale short-run colour printing. Even larger displays can be made from strips of media output in tiles or sections.

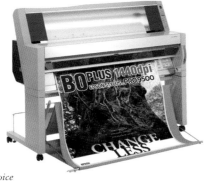

Photoquality inkjets printers such as this Epson 890 are low-cost but high-quality devices. With the ability to print on custom paper shapes and sizes, such as this panoramic print, printed from a roll-fed paper source, this type of inkjet is an ideal starting point for a new user.

receiving paper costing more than equivalent-size photographic paper. Priced at four times the cost of a professional inkjet, the dye-sub printer is no longer a competitive option for keen photographers. Queries have arisen over the stability of these dyes, particularly when prints are placed in contact with protective plastic sleeves. There's much less creative intervention possible with this type of device, no textural papers and no special ink sets.

Solid ink printers

Solid ink printers use sticks of crayon-like ink which are heated and dropped on to paper. These devices were the first to be able to print on widely different paper surfaces. Unlike the dye-sublimation and wax-transfer systems, art papers of varying weights and textures could be used. On the downside, the image quality is not as photo-realistic as an inkjet and the device does not render fine text detail particularly well.

Colour laser printers

Lasers work in a very different way to the previous devices, with the printer fusing dry pigment or toner onto papers of various surface finishes and weights. The quality of continuous tone images is not high, as different colours are created by fairly crude halftone screens. Despite the high quality of 600 dpi monochrome lasers, which are excellent for DTP, colour lasers do not produce an image as sharp, and are best used for rough layout proofs only.

Fuji Pictrography

Like the Fuji Frontier, the Pictrography uses a laser diode to transmit the digital image onto colour photographic paper. The resulting print has the same quality that you'd expect from a colour film original. Imaged line by line onto light-sensitive donor paper, it's then transferred to receiving paper and peeled apart, much like a professional Polaroid. Pictrographs can be made up to A3 in size, with resolutions up to 400 dpi, making super-sharp results, which are indistinguishable from standard photographic prints. The Pictrography does not need any chemical supply or replenishment, only water, which is a more environmentally friendly alternative to chemical photography. The relatively high cost of the unit and specialised sensitive materials makes it only viable for photographic labs or professional photographers who spend a small fortune on lab printing services.

Pro lab output Fuji Frontier

Perhaps the most revolutionary device to hit digital printing over the last two years has been the Frontier minilab. Using a laser diode to 'beam' an image onto conventional photographic paper, this device takes advantage of all the benefits of a digital original and conventional photo paper output. Digital files are generated by scanning negative film as part of a standard C41 processing sequence, then stored on an internal hard disk. A wide variety of enhancements can then applied such as sharpening, colour balancing and sepia toning, giving a higher quality result compared to a lens-driven printout. Excessively dense 'holes' found in shadows and highlight areas are minimised by the Frontier software, producing a near hand-printed finish. There's no dust, scratches or drying marks either.

Many on-line labs use Frontiers and accept digital files by email, print them out and return by post.

Other digital output types

Thermal wax printers use lower temperatures to heat pigment-carrying wax from a print ribbon. Faster than dye-sublimation printers, the thermal wax printer's major disadvantage is its reproduction of colour through a halftoning, or dithering process, together with an inability to use special papers or media.

Indigo digital litho

For output directly from disk, a digital litho press like the Indigo bypasses the need for high-cost film and printing plates. This type of service can be very economic for short-run printing and each copy can be individually personalised with the recipient's name etc. With a smaller range of paper stock and weights compared to traditional ink-based litho, digital litho is still an emerging technology.

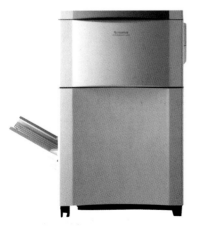

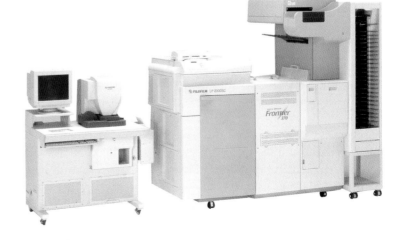

How inkjet printers work

Inkjet technology is based on lithographic reproduction, the process used to print all of our magazines and books. The illusion of a photographic print, usually made from millions of different colours, is mixed from only four or five individual inks.

Unlike the microscopic dye particles in photographic film and paper, which describe the many subtle colour variations in an image, an inkjet uses a different method. Halftoning has been in use since lithographic printing livened up printed packaging and newspapers with photo-real illustrations. Based on the limitations of the four CMYK ink colours, known as the process colours, each colour image is constructed from millions of tiny dots of different sizes and distances from one another. Viewed from a distance, these dots are optically merged by the viewer to give the impression of subtle colour changes. All magazines and books with photo-real illustrations are produced using halftones. Inside an inkjet printer head is a series of nozzles, each capable of dropping a variable-sized dot onto receiving material such as paper. At maximum quality setting, each nozzle drops ink, but at draft resolution setting, many remain closed.

Printer resolution and image resolution

If you're confused by manufacturers' claims that a printer outputs at 1440 dpi, it's worth bearing in mind that these are not separate dots occupying their own individual space, but overlapping. You'll gain no advantage in having an image file with a resolution in excess of 200 ppi.

Software controls

Surprisingly, the many pre-set options offered by the printer software dialogue box will have a profound effect on your output. To match different media types such as glossy, matt or film, the software options are provided to help the printer drop the right amount of ink at the right resolution. If you pick the wrong options, the results will not do your image justice. It's no surprise that results are far better when you use the recommended combination of ink and paper together, as each has been formulated to bring the best out of each other.

Maintenance

Printer heads become blocked very easily, especially if using pigment-based inks. The tell-tale sign of this is an unexpected colour cast or visible lines in your printout. As one or more inks are not emerging from the tank, the colour balance is unduly influenced. There's a simple software routine to flush out blocked nozzles which takes a couple of minutes. It's good practice to do this head-cleaning exercise before you settle down to a long session of work. Another frequent problem is printer-head misalignment, which can occur after using thicker or textured media. As each colour has its own individual set of nozzles, they can be pushed out of register with the rest.

Screening techniques

There are many different halftoning methods used to create the visual illusion of tone and colour. The dot screen is the most commonly used in commercial litho printing whereby each process colour is separated into a regular grid of dots. Inkjets use a less geometric plan called stochastic screening, where the powerful printer software determines the position of each dot where it's needed most. Sometimes called dithering, this method can reduce the appearance of visible ink dot patterns in your final print. To prevent the visible signs of banding, a poor by-product of early and cruder inkjet printers, a good option is to use the Microweave setting in your printer software controls. This helps to slightly overlap lines of ink and reduce banding.

Colour and media limitations

Of course, not all colours can be mixed from such a limited palette of inks. Metallics such as gold and silver and fluorescent colours can't be reproduced by CMYK inks. The physical characteristics of each media type, such as surface texture, absorbency and the kind of raw materials it's made from, will also determine the kind of results you can hope to expect and what you can't possibly achieve. Simple techniques for working with each different media type are provided in chapter 9.

Chapter 2

IMAGING FUNDAMENTALS

---⟩ Image resolution

---⟩ Scanning techniques

---⟩ Scanning different originals

---⟩ Digital camera data

---⟩ File formats

---⟩ Using Adobe Photoshop

---⟩ Setting up your workstation

Image resolution

The quality and print potential of a digital image is described by its resolution.

All photo-real digital images are constructed from pixels. Like a mosaic, a pixel-based image is made from regular-sized components arranged in a grid called a bitmap. Each pixel has its own unique position in the grid and is assigned an 'address' using vertical and horizontal coordinates, a bit like a map reference. Sometimes digital images are described in pixel dimensions, e.g. 1800 x 1200 or 640 x 480, a measure of the horizontal and vertical sides. Bigger pixel dimensions give you better results.

Megapixels

Just to confuse things further, many digital camera manufacturers use the term megapixel to describe the pixel dimension or 'size' of a captured image. A megapixel value like 4.7M is arrived at by multiplying the horizontal and vertical pixel dimensions together. As before, the bigger a camera's megapixel value is, the better and bigger print you can make with it.

Bits and bytes

Unlike humans, computers use the binary number system rather than the more familiar decimal one. Binary uses two digits: 0 and 1. Of course you can only describe two states with a single digit binary number, such as off or on, or if they represented colour or black or white. If you increase the number of digits to two,

you can represent four states or colours and so on. The common palette for photo-real digital image is 24 bit, made from three 8-bit scales, one each for Red, Blue and Green. Although many hardware devices such as film and flatbed scanners capture in a higher bit depth such as 36 or 48 bit, output devices cannot cope with anything more than a 24-bit instruction. Such images need to be resized, known as resampling, before printing.

Colour depth

In addition to the placement of pixels in the bitmap, a unique set of instructions are needed to determine individual pixel colour. Pixels are mixed from only three ingredients, Red, Green and Blue, and each ingredient is drawn from its own 0–255 scale. Zero is always black and 255 is always white, and in between is a brightness scale. The recipe for a single pixel may look like this: R34 G120 B156. The term 'colour depth' is used to describe the size of colour palette.

High resolution and low resolution

In digital imaging, the term resolution is used to describe overlapping meanings. In very general terms, high-resolution images are made from millions of pixels and millions of colours and are designed for printing out. Low-resolution images have perhaps less than a million pixels and are

Close up, digital images resemble a mosaic, with each square pixel evident. ▲

The colour 'recipe' for a pixel uses only three ingredients: RGB. This brown pixel is mixed from these three values.

1-bit images can only display two tones, in this case black or white. Lineart or Bitmap mode images are 1 bit.

2-bit images can display four tones and starts to hint at a three-dimensional object.

3-bit images can display eight tones and further improves the quality of the illusion.

8-bit is the common palette for a grayscale image. Human vision is unable to detect any banding or steps from this palette of 256 tones.

Colour images, like those saved in the GIF format, can be made with an 8-bit palette. However, results are not photographic quality.

The 24-bit colour image is the common currency for desktop output devices like an inkjet.

only suitable for computer monitor display. High-resolution images are constructed from a 24-bit palette (or more) and have no visible steps or bands to the naked eye.

Vector images

Another type of digital image is the vector image as created by drawing applications such as Adobe Illustrator and Macromedia Freehand. Vector images are not constructed from pixels, but complex outlines accompanied by colour-fill instructions. Many cartoons, like the infamous **South Park** are created with vector drawing applications, as are Flash web animation sequences. Vector files have a tiny data size. You can't get photographic quality from a vector image and you usually need a Raster Image Processor (RIP) to help an output device to convert vector instructions.

Scanning techniques

Scanning originals is just like developing film: you need to exercise careful control of contrast and density. You can rescue bad scans with software trickery, but it's far quicker and easier to start over.

Both dense and thin negatives are a challenge to print, even before you get to the creative bit. Bad scans are just the same; you'll spend more time resuscitating rather than interpreting. Like digital cameras, flatbed and film scanners are fitted with light-sensitive detector cells, called CCDs, which work like individual cells in an insect's eye. Each sensor cell creates an individual pixel in the resulting digital image, and the more cells your device has, the bigger print you can make. The resolution of a scanner, or its ability to capture fine detail, is directly related to the number of sensor cells. A 600 dpi (dots per inch) flatbed scanner for instance will have 600 different sensors running across the width of the bed and a 1200 dpi device has twice as many. Surprisingly, scanners capture and create far more digital data than current state-of-the-art digital cameras, and so offer a much more cost-effective way to get into digital photography.

Scanner software
Scanners are operated through two types of software: either a small stand-alone application or a Photoshop plug-in. Many devices are supplied with both, leaving you to decide which is the most convenient. Stand-alone software takes up much less of your computer's memory resources and may allow faster transferral of images to your PC, if you have the minimum amount of RAM installed, or if you want to scan in large quantities of images quickly. A plug-in enables you to operate the device within Adobe Photoshop after a File····>Import····>Plug-in software command. With a plug-in, once scanning is complete, the scanner software closes automatically and you are left in Photoshop to manipulate your image instantly. Another option is via the TWAIN interface. TWAIN, bizarrely, stands for Toolkit Without An Interesting Name and is essentially like a software travel plug, allowing digital images created by many different third-party devices to interface with Adobe Photoshop. Photoshop supports TWAIN, so any TWAIN-compliant device will work within it

Quality factors
Both film and flatbed scanners are made with different sensing capabilities. The first consideration is the number of different colours a scanner can detect in your original artwork. Referred to as bit depth or sometimes colour depth, think of this like an artist's palette of colours. If you are an artist, you can paint more realistic pictures with a greater range of colours on your palette. If you are a digital artist, you need to use a palette with 16.7 million different colours (commonly referred to as 24-bit) to make

Flatbed scanners are a low-cost way of digitising printed photographs and other flat artwork. Even low-cost devices produce enough data for top-quality inkjet output.

Film scanners are capable of extracting over 30Mb of 24-bit RGB data from a 35mm film original, more than enough to make an A3 print.

a photo-realistic picture. Most software and photo printers can't process anything in excess of 24 bit, so this has become the common standard. Yet many scanners can detect far more than this: for example, a 42-bit scanner can detect billions of colours. Yet, once captured, these super sampled images have to be scaled down to the standard 24-bit vehicle. You'll be unlikely to see any difference between the same image scanned by a 36-bit compared to 42-bit device.

Resolution

Resolution is the next key issue and refers simply to the number of pixels the scanner can create from an inch of picture information. Many flatbeds are described by two measurements e.g. 600 x 1200 dpi, (width x length). The highest figures denote the best device, but you are unlikely to see any significant quality increase between a 600 dpi and a 1200 dpi device when scanning photographic prints. Film scanners, however, are designed with sensors which have much higher resolutions than flatbeds, because 35mm film originals are much smaller, typically 24 x 36mm in size. So film sensors have to be smaller and film scanners need more of them to pull out picture information lurking in tiny film frames. Good 35mm film scanners have a resolution of around 2400 or above, extracting a huge 20–30 Mb worth of information.

Optical and interpolated

Just to confuse you, resolution is often quoted in two values: optical and interpolated. Optical gives you the true hardware specification, e.g. the actual number of sensor cells your scanner is fitted with. Interpolation, however, indicates how much your image can be enlarged by software trickery. Remember that with an interpolated image, new pixels are squeezed in between original detected ones, and their colour is guessed by averaging out adjoining values. Interpolated images never have the same sharpness or quality as optical scans, so even if your scanner can 'capture' at 9600 dpi, it won't necessarily be any good.

Dynamic range

The term dynamic range is generally quoted on professional film scanners only and refers to the scanner's ability to detect detail in an original's highlight and shadow areas. Photographic film, particularly transparency, can have very dense shadow areas, proving too black for a desktop model to cope with. In practice, a mid-price model will be perfectly adequate as you may want to scan trannies very occasionally and, if they are well exposed, they may have only tiny shadow areas anyway. Better or repro-quality devices, which can have a dynamic range of 3.0D and over, can deal with these difficult tasks. Density is never a problem if you shoot and scan colour negative film.

Computer interfaces

To cope with the transfer of large packets of data from a scanner to your computer, a range of different connecting cables are used. Firewire is currently the fastest, followed by USB and SCSI. Many older computers will not have the corresponding connector, or port, to support newer devices, but this problem can easily be solved by installing a PCI card. This is a more satisfactory (and usually cost-effective) method compared to using cable adaptors.

SIX RULES FOR GOOD SCANNING

1. Always do a preview scan, as this helps your scanning software to judge 'exposure' by looking at highlight and shadow areas of your image.

2. Fit the marquee tightly around your original, as white space will be converted into pixels and increase the data size of your scanned image document. Additional white space will be perceived as an image highlight and will adversely affect your 'exposure'.

3. Check you haven't got any preset preferences turned on, like a sharpening or descreening filter. Test out any preset or auto scanning routines before you rely on them, as you may get better results with a straight scan. Presets may force out the subtleties present in your original image.

4. Avoiding an increase in contrast is the key to good scanning. Always scan low contrast then restore it in your more sophisticated imaging application.

5. Don't expect to make a pin-sharp A2 poster from a postcard-sized original, so be realistic about enlarging. Scan the largest original you can.

6. Avoid using contrast control functions unless the preview image is of a high quality. Many scanner interfaces present you with a very low-grade preview image, which will never give you an accurate indication of highlight and shadow areas.

Scanning different originals

In conventional photography different subjects demand different techniques and materials for good results. Scanning different kinds of artwork also requires the right approach.

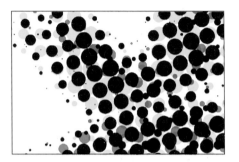

Black and white photographs

Mode: Grayscale.

Flatbed Input Resolution: 200 dpi for inkjet, 300 dpi for litho output.

Film scanner Input Resolution: Use highest available.

Filters: Sharpening OFF.

Presets: Avoid using any contrast increasing Auto function.

Save As: TIFF format.

Photoshop processing

1. Set Highlight and Shadow points in Levels.
2. Adjust Levels midtone sliders to correct brightness.
3. **Image Size:** Reduce the pixel dimensions to fit your paper.
4. Sharpen with 'Unsharp Mask' before printing.

Tips: Avoid scanning prints with a lustre or stipple finish as the texture will be evident after scanning.

Colour photographs

Mode: RGB colour (24-bit minimum).

Flatbed Input Resolution: 200 dpi for inkjet, 300 dpi for litho output.

Film scanner Input Resolution: Use highest available.

Filters: Sharpening OFF.

Presets: Avoid using anything that claims to match an output device.

Save As: TIFF format.

Photoshop processing

1. On the composite RGB Levels channel, set Highlight and Shadow points and adjust midtone slider to correct brightness. Correct colour balance.
2. **Image Size:** Reduce pixel dimensions to fit your paper.
3. Sharpen with 'Unsharp Mask' before printing.

Tips: If your scanner captures in 36 or 48 bit, make sure you convert your image back to 8 bits per channel before editing.

Colour images from magazines or books

Mode: RGB colour (24-bit minimum).

Flatbed Input Resolution: 200 dpi for inkjet, not suitable for litho output.

Filters: Descreening ON, Sharpening OFF.

Presets: Avoid using contrast increasing Auto function.

Save As: TIFF format.

Photoshop processing

1. As for Colour Photographs. You can only do limited manipulation before your image is overcooked.

Tips: Don't expect pin-sharp results from your scan. The descreening filter applies a blur to the image, so the individual ink dots (above) are blended together. Sharpness is then regained by using the Unsharp Mask filter in Photoshop. For mono images, scan as for B&W Photographs, with Descreening filter on.

3-D objects

Mode: RGB colour (24-bit minimum).
Input Resolution: 200 dpi for inkjet, 300 dpi for litho output.
Filters: Sharpening OFF.
Presets: Avoid using anything that claims to match an output device.
Save As: TIFF format.

Photoshop processing

1. Isolate the object from the background using the Pen tool.
2. Convert Path into a selection and delete the background. (Rename Background Layer if you can't cut away to transparency).
3. Now set Highlight and Shadow points and adjust midtone slider to correct brightness using the composite RGB channel in your Levels dialogue.
4. Correct colour balance.
5. Sharpen with USM (just before printing out).

Tips: You can get about two inches of 'depth of field' sharpness from a 3-D object. Drape a piece of white card over your scanner platen to stop any ambient light from spoiling the results. Tell-tale error colours like magenta will appear in highlights, but you can drain this away using the Sponge tool set to Desaturate.

Line art

Mode: Bitmap.
Input Resolution: 600/1200 dpi.
Filters: None.
Contrast controls: Use Threshold slider to determine 'exposure'.
Save As: TIFF format.

Photoshop processing

1. You may need to remove stray black pixels with the Eraser.
2. When re-opened, Photoshop asks you to choose the working resolution for your Bitmap eg 300 dpi and reduces or enlarges as needed.

Tips: Line art is a blanket term for a single-colour original that has not gone through a halftone, i.e. made from solid colour rather than dots. Scanning controls are limited to a Threshold slider. If your scan subject looks thicker than the original, then rescan and use a higher Threshold (exposure) setting. If it looks thinner, rescan and use a lower Threshold value.

Aliasing is most visible in single-colour artwork, hence the reason for scanning at a super-high resolution. Artwork such as a pencil drawing including grey tones should be scanned as a Grayscale, not a Bitmap.

Enlarging

Think of this like the enlarge/reduce button on a photocopier. If you scan a 6 x 4 photo print, at 100%, @ 200 dpi and output to an inkjet without resampling, you'll end up with a 6 x 4 inkjet print.

Like a photocopier, you can enlarge smaller originals, but they will lose sharpness as they get bigger. Interpolation or resampling adds extra pixels in between original detected ones, but will not give the same quality as scanning from a larger flat original or using a higher input resolution.

Quality of originals

Colour photographic prints from high street mini-labs are rarely pin-sharp and sensitively printed, so any scan you make will merely echo this. You can pull much more and better-quality data out of a 35mm film original than you can from its 6 x 4 proof print.

Scaling factors

For lithographic printing, a general principle is to set the input resolution at double the screen frequency or ruling. Most colour litho work is output at 133 or 150 lines per inch, so an image at 300 dpi will suffice for most situations and can be reduced to 266 dpi without much loss of quality. If more than one pixel is available for the printed dot, less problems occur.

Dropper tools

When originals contain excessive highlights like burnt-out flash spots, dropper tools can be used to select a different white point. Droppers can be used to reset problem black points or darker midtones.

Digital camera data

The quality of a digital print is irretrievably linked to the quality of the source data. With a digital camera, it's essential to double check your settings before shooting, because you can't put back detail later on which wasn't there in the first place.

By far the biggest disappointments are caused by images created by digital cameras at low-quality settings. With storage space at a premium, digital cameras offer greater capacity by saving images as low-quality JPEGs. You'll never get good results from these files, so choose Finest or High quality as your capture mode and buy a bigger memory card.

In addition to quality mode, your digital images will be defined by their pixel dimensions such as 1800 x 1200. When printing out, you and only you determine the size of your pixels. At one pixel per inch, they'll be big and very visible, but at 200 pixels per inch they'll be completely invisible.

To get a photo-realistic print using an inkjet printer you need to make sure your image is output at 200 pixels per inch (same as dpi or dots per inch). If your camera creates 1800 x 1200 sized images, this means you can make a 9 x 6-inch print at 200 ppi.

In practice, you can always enlarge your print without too much loss of quality by dropping it from 200 to 180 ppi. If you start to see square pixel shapes on your print, then you've dropped the ppi down to far. When buying a camera, it is uninterpolated pixel dimensions that will help you work out the maximum print size you can achieve.

Five tips for shooting with a digital camera

1. Leave sharpening filters switched off as you'll get much more control using the Unsharp Mask filter in your imaging application. Over-sharpened images can't be corrected at a later date.

2. If your camera has a variable ISO, use the lowest setting your lighting permits for best results. Noise, like film grain, will become more visible as you increase the ISO speed.

3. Once transferred to your PC and before you start any creative work, save the JPEG image documents in the TIFF or Photoshop format, so you won't lose any quality. Resaving JPEGs will make your images lose sharpness.

4. Don't be too despondent with raw JPEG results; they'll be unsharp, low contrast and low saturation, but easily brought back to life in Photoshop.

5. Experiment with your camera's white balance settings until you find a suitable one. Some cameras produce 'cold' results on Flash setting and even stranger outcomes with Artificial light settings. Both could impose a colour cast that's tricky to remove.

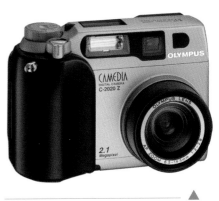

All digital camera have different quality sensors, described in megapixels. The bigger the megapixel value, the bigger print you can make. This camera has a 2.1M sensor.

A digital image can be measured by its pixel dimensions. The 2.1M camera above produces 1800 x 1200 pixel images, estimated as follows: 1800 x 1200 = 2,160,000).

All digital cameras produce images that have low contrast and low colour saturation. Fewer colours make smaller image files, and this is a more efficient way to cram as many images onto digital camera storage cards.

All digital camera images need minor processing before printing. After restoring colour saturation and contrast, results will far exceed prints made straight from unprocessed files.

Like photographic film for conventional cameras, digital cameras can be used at varying ISO or film speed ratings. Like film, the best image quality results from using the camera at the lowest ISO setting.

When set to high ISO values like 1600, needed to shoot in low light conditions, lower-quality images are created. High-speed photographic film makes grainy prints, and similarly digital cameras produce 'noisy' images, characterised by brightly coloured pixels placed at random. Noise is usually more visible in shadow areas.

File formats

It's essential to save your work in the right file format if you want to store it at top quality and transport it to other workstations and applications.

Image documents can be made in all shapes and sizes for a wide variety of purposes. Each different type, known as a format, allows you to configure the image data for future use in specific applications like QuarkXpress, or for more general use, e.g. on the Internet. Different formats can be identified by the three-digit code attached to the end of your document name such as landscape.tif, denoting a TIFF file type, or logo.jpg, describing a JPEG file type. Most file formats are generic and are available as 'Save As' options in both amateur and professional software applications. More complex file formats such as the Photoshop or .psd format is limited to its host application and a few selected others in the professional software range. This .psd format is the only one that lets you keep your work saved in layers, a good idea if you want to make future alterations.

Other file formats have been designed to let you downsize image data, a process called compression, taking up less storage space or for fast network download. The two most used compression formats for print output are JPEG and TIFF. These use two different styles of compression called Lossy and Lossless. Lossy methods as used in the JPEG format, loses image quality each time an image document is resaved, making a crude patchwork of blocks which ruin any detailed areas in your image. JPEGs should be considered only as a last resort for storage. The TIFF format has a variant which uses a lossless compression routine and can be safely used without any danger.

If you need to visualise this process, imagine the compressed TIFF format like rolling up a large photographic print. Once unrolled there will no evidence of damage. The lossy JPEG format, however is a bit like folding the photograph into pocket size and when unfolded, 'crease' marks will be very obvious.

It is worth remembering that in these days of high-capacity hard-disk storage, compression may not be an issue for your work. But if you plan to swap, share or buy professional output, you will need to make sure you use a universal file format, such as TIFF, or your work will not be recognised by other users' software. If you plan to work at home, on your own system, then use the versatile Photoshop format to save your work.

CompuServe GIF

Graphic Interchanged Format is never used for print purposes, but for monitor display. Millions of colours, forced into a palette of 256 colours or less, use a crude method of illusion called dithering. You can't convert GIFs back to 24-bit RGB to reclaim lost detail and if you try and print out, you'll get a disappointing result.

The Photoshop file format allows you to save and store your work in layers, a vital function for work in progress.

GIF images are designed for monitor display and then only for graphic images with hard-edged shapes. When downloaded and printed out, this is the kind of result you'll get.

JPEG or JPG

Designed by a research team called the Joint Photographic Experts Group, the JPEG format is the standard for digital cameras. Unfortunately the ideal scenario of high image quality and tiny data size are opposing forces. If you want to compress your data to a tiny file, you have to settle for poor image quality. If on the other hand you want to keep maximum image quality, your file size won't shrink down as much. On digital cameras, there's usually three to five different quality settings, which are really different levels of JPEG compression. The lowest JPEG setting will enable you to shoot and store the most images on your memory card, but image quality will be terrible when printed out. The best option is to choose the highest or next highest setting and after downloading to your computer, save files in the TIFF format to stop them losing quality. Never shoot low-quality JPEGs as you won't be able to rescue sharp detail at a later stage. Images downloaded from the Internet will rarely print out well either, because they have been created as low-quality JPEGs for fast network transmission. With a tiny file size, these images are meant for onscreen use, rather than printing out. JPEG 2000 is a new format offering the ability to assign different levels of compression to different areas of your image, but is as yet largely unsupported by imaging applications.

TIFF

Tagged Image Format File or TIFF is a universal file format for bitmapped images. There's a compressed variant too, which uses a sequence called LZW and works without any visible loss of image quality. You can reduce your document size by about one third of its original size. Both Mac and Windows PC versions exist. If you are ever in any doubt about the right format to submit work in, for publishing or lab output, choose the TIFF format.

EPS

Encapsulated Postscript files are for use in desktop publishing programmes like QuarkXpress and PageMaker. Most digital images are rectangular, but EPS files can contain a special edge called a clipping path for making irregular image shapes known as cut-outs. Magazine spreads which have irregular images use EPS files in their layouts. You don't need to convert your images into EPS files for desktop print out, there are much simpler ways to print unconventional shapes (see page 88).

Photoshop

The PSD format lets you save additional image information for later use such as extra layers, masking channels, paths and even captions. If you want to save a layered image in a different format, such as TIFF, you need to flatten it first. With software companies bringing out updated products every eighteen months or so, different versions of the Photoshop file, such as v6.0 is not backwardly compatible and can't be read be earlier versions of the software like v4.0.

PDF

Adobe's innovative Portable Document Format generates a unique file format that needs its own reader software to be opened and viewed. PDFs are data-lean, platform-independent and much used on the Internet to provide high-quality manuals for download. All original layout and design is retained in a PDF file with type and graphics printing out pin sharp.

File type	Data compression	DTP use	Internet use	Layers	Saved selections	Saved paths
Adobe Photoshop (.psd)	✘	✘	✘	✔	✔	✔
Gif (.gif)	✔	✘	✔	✘	✘	✘
JPEG (.jpg)	✔	✘	✔	✘	✘	✔
Photoshop EPS (.eps)	✘	✔	✘	✘	✘	✔
PICT (.pct)	✘	✘	✘	✘	✘	✔
PNG (.png)	✔	✘	✔	✘	✔	✔
TIFF (.tif)	✔	✔	✘	✘	✔	✔

Pixel images can be incorporated into PDF documents in different qualities. Most professional imaging software can open and read PDF documents but you need special Adobe PDF Distiller software to generate your own PDFs.

Lossy compression

JPEG files allow image data to be greatly reduced, or compressed, by generating a generalised colour value to a block of pixels, typically 9 x 9, instead of each individual pixel. You can determine the extent of these savings by choosing a variation on a 0–10 or 0–100 scale. At a low setting (high data saving) image quality will drop, most noticeably in gradient and patterned areas. Known as lossy, your image will get worse if you resave.

Lossless compression

Tiff files can be compressed too by using a different method to JPEG, called LZW. Without causing perceptible damage to your image quality, the savings at best will be about a third of the file size. This routine looks for strings of similar coloured pixels and creates a reduced instruction for the sequence. If saving Tiff files using LZW, choose the PC option as this is most compatible for future use between the two platforms.

Swapping between computer platforms

If you need to work on both Windows PC and Mac systems, then you need to have a file extension on the end of your document. JPEG, PSD and TIFF file formats can easily be read on both. Unlike PCs, Macs do not automatically enter the file extension after the document name unless you set this function up in the application preferences. In Photoshop do File···➤Preferences···➤Saving Files and choose Always from the Append File Extension drop-down menu.

JPEG images are designed to save on data by assigning colour values to blocks of pixels, rather than each pixel individually. Greater compression of data results in poor image quality which gets worse each time you resave.

In comparison, an uncompressed image will have sharper detail and will not deteriorate over the course of a creative project.

Other file formats

Many digital cameras store images in a non-standard format, such as FlashPix. A software plug-in is usually provided with the camera to help Photoshop to open the images after download. After opening, save the image in a more recognised format such as TIFF. The Photo-CD format is copyright reserved by Kodak and although most applications can open Photo CD images, none can save images in the Photo-CD format. You can get your images made into Photo CD via most high street photo processing labs as an add-on to a develop and print package. The Kodak Picture CD, aimed at the amateur market, is a cheaper service but uses a lower-quality JPEG format.

Disk formats

Document file formats are not to be confused with formatting disks or disk formats. Formatting is a totally different process used on hard disks and removable media like floppy and Zip disks to lay down a 'foundation' before they can be used. Writable CDR and CDRW disks can also be formatted for customised purposes such as cross platform.

Archiving image files

Once you've finished with your image file, it's essential to store it in the RGB colour mode and no other. If you need to convert your image into CMYK for commercial reprographic output, always keep an RGB copy. When conversion takes place, the shadow values in each RGB channel are assimilated to make the new black channel in the CMYK. Problems occur when converting CMYK back to RGB, as the black channel often attempts to split back into RGB shadows, often with poor-quality results.

Image modes

The innate characteristics of black and white and colour photographic films are mirrored by different digital image modes. Like film, image modes exist for specific final uses.

If you visualise digital image modes like different photographic film types, you are well on the way to understanding their purpose. Modes are essentially there for you to prepare your image in the most appropriate way for future output.

RGB mode

Unlike other modes, RGB can use all of Adobe Photoshop's functions. Split into three colour channels plus the composite RGB (found at the top of the channel's palette), RGB is the standard mode to use for colour inkjet output. 24-bit is standard.

Grayscale mode

Like shooting black and white positive film, grayscale has only one channel, black, and cannot contain colours, unless first converted to RGB. 8-bit is standard.

CMYK mode

There's no reason to edit in CMYK unless the end use is litho output and many Photoshop functions are not available in CMYK mode. The CMYK colour space is smaller than RGB and colours will look duller on screen. Best is to work in RGB mode and have the CMYK Preview function switched on, (View ·····> Preview ·····> CMYK) which allows you to have all the benefits of editing in RGB, plus a visual estimate of the results, before converting.

LAB mode

LAB mode is a theoretical space, i.e. not connected with an input or output device. With three channels, one for lightness and two for colour, LAB can be used to make good quality conversions from RGB to Grayscale without muddy results.

Bitmap mode

Only used for capturing single colour artwork like drawings or type. Bitmaps are 1-bit, so have a tiny file size. Editing tools in Photoshop are very limited. Once reopened, bitmaps can be adjusted to the correct working resolution without much loss of sharpness.

Multichannel mode

Duo, tri and quad tones are ordinarily set as single channel images; you can split each colour used into a separate channel to view, but not edit the results. Used in the preparation of litho plates only.

Index mode

Unlike the other colour modes which split image colour into different channels, Index mode crams all the colours into one.

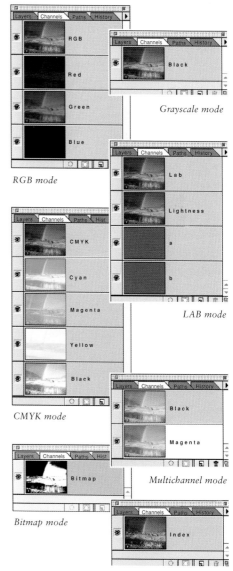

Grayscale mode

RGB mode

LAB mode

CMYK mode

Multichannel mode

Bitmap mode

Index mode

Using Adobe Photoshop

Adobe Photoshop is a highly sophisticated application used for technical and creative image processing. For digital printing, it gives you all the tools you will ever need.

The professional version of Photoshop retails at a high price for the keen amateur, but like a good-quality lens, you'll never look back once you've bought it. At four times the price of other applications like Jasc PaintShop Pro and MGI PhotoSuite, Photoshop gives you all the tools you'll ever need to generate top-quality results.

Currently there are three different variations of the application: Photoshop LE, Photoshop Elements and the full version called simply Photoshop. Starting at the bottom, Photoshop LE is often bundled freely with scanners, printers and digital cameras. LE is essentially a cut-down version of the full package and offers all the basic tools for contrast correction, colour balance and filtering. Missing are the essential History palette, for reversing commands made in error, and the automated Actions for speeding up repetitive tasks.

Next is the recently introduced Photoshop Elements, pitched at a quarter of the cost of the full package and offering substantially more than LE. Elements is good value and an ideal starting point for a new user. It comes complete with full manual. The friendly interface is designed with a new user in mind and displays the most useful tools on the desktop, not hidden in drop-down menus. There's a helpful Hints palette to guide you through the basics, plus full History and an Action command variation called Effects. Photoshop's full version, currently v6.0, includes a host of precision tools for colour management and manipulation, plus the ability to work in different colour modes such as Duotone, CMYK and LAB. With more tool and functions, there are many more ways you can separate and extract the essential parts of an image for creative manipulation.

The Photoshop desktop

With palettes and menus taking up screen space, a good-sized monitor will give your image a large display area.

Selecting tools

Selecting or isolating the part of your image for manipulation is the key to using Adobe Photoshop. Like highlighting a word in a word-processing document, selecting allows you to make alterations in a local area without damaging the surroundings. You can make selections by area, colour or brightness. The selection tools found in the upper quarter of the toolbox allow you to draw a dotted line around your chosen area. Like a fence, this dotted area encloses the parts to be modified without damage to the outlying area. The Magic Wand works like a magnet by attracting pixels of a similar colour value into a selection area. You can change its strength

Selecting effectively draws a fence around an area of your image, as above.

You can also use Quick Mask mode to protect, or mask off image areas, as shown here in red.

by modifying its Tolerance value. If you like the idea of using the old process of masking with photographic opaque, then working in Quick Mask Mode is for you. Click on the Quick Mask button and use any of the painting tools to make a stencil. Click back to Normal mode to see the selection boundaries. The most precise selecting process uses the Pen tool to make a different kind of outline called a Path. Paths are drawn with Bezier curves, tools used in vector drawing programmes like Adobe Illustrator. Bezier curves can be modified to fit the exact shape and are the most effective way to make cut-outs for montage projects. Paths can be saved with little addition to your document's data size.

Layers

Layers are the most important difference between conventional darkroom and digital printing processes. With layers, everything is reversible, originals are never at risk and important creative decisions do not have to happen in a pressurised linear fashion. Working with layers amounts to working at your own pace and with as much experimentation and diversion as you can summon. A single layered image is like an original negative: easily damaged in use, with irretrievable consequences. Layers provide many functions, they can keep separate ingredients for a montage, hold work in progress until it looks ready and hover technical settings like contrast until you are ready to commit. Layer blends have no real-world parallels, allowing you to merge two layers together at the expense of certain colours or tones. The downside to using layers is that they increase your document's data size and could prove

unmanageable if you have a slower machine or limited RAM resources. Only one file format supports layers: the Photoshop format (.psd).

The Channels palette

You can split a digital image into its component colour channels to make selecting a shape or tone much easier. Each different mode is characterised by its different channel split. RGB has three channels, CMYK four and LAB three. By clicking on a channel of your choice, you can also apply a creative or technical enhancement like a sharpening filter. Alpha channels, looking like simple black and white stencils, are created when you save a selection and can be modified using the drawing tools.

The History palette

During your working session, the History palette records all the different stages of your image. In effect a full-sized version of each and every state is held in your computer's scratch disk memory, which is recalled and brought forth whenever you click on a History state. History is usually set at the last twenty commands, but you can change it to record up to 100, provided you have enough scratch disk space. If you like the idea of saving variations of your image throughout a session, perhaps to print out at a later stage, click on the button on the bottom of the palette called Create New Document from Current State.

The toolbox

If you are used to working in a traditional graphic design studio, commercial printing or a photographic darkroom, then the toolbox will contain familiar-looking

devices. More in-depth information on each tool can be found in the application's manual and you will benefit greatly from following the accompanying tutorial.

Learning time

Perhaps the hardest phase for a new user is the beginning, with little reward to show for many hours' work. Yet once you are familiar with the basic processes and the right work sequence, your work rate will speed up enormously. Always have the History palette on your desktop; in addition to remembering your previous commands, it also names them in case you do something without realising.

Keyboard shortcuts

If you are an intermediate user, try and learn a couple of new keyboard shortcuts during each session. Get used to keeping your non-mouse hand over the Shift, Command (Cntrl) and Alt keys and follow the manual for instructions. Each tool in the toolbox can be selected by typing an appropriate key e.g. T for Type tool and V for the Move tool. Time saved flicking back and forth to your toolbox can be spent on more creative tasks.

Useful shortcuts

Zoom in: Space bar + Command/Cntrl (PC)
Zoom out: Space bar + Alt
Moving: Space bar + click hold and drag your mouse
Undo: Command/Cntrl (PC) + Z
Undo again: Command/Cntrl (PC) + Alt + Z
Hide Edges: Command/Cntrl (PC) + H
Levels: Command/Cntrl (PC) + L
Curves: Command/Cntrl (PC) + C
Colour Balance: Command/Cntrl (PC) + B
Save: Command/Cntrl (PC) + S
Save As: Command/Cntrl (PC) + Shift + S

Setting up your workstation

Working on a badly set-up workstation is like driving an expensive car in second gear. Accurate colour balance and workflow can be greatly enhanced if your computer is properly tuned.

It's important to situate your workstation in the right place, to avoid excessive light and cramped conditions. In order to minimise reflections on your monitor, don't place it facing a window or bright lights. For accurate analysis of colour prints, opt for diffused natural lighting rather than direct artificials in a white-walled room. Domestic lightbulbs will impart an invisible orange ambience to your room which will adversely impede your colour judgement. If daylight isn't an option, use overhead fluorescent strip lighting with daylight corrected tubes.

Electrical supply can also be an issue, especially if you have a couple of plug sockets to hand. Don't try and run everything off one single plug and if you are uncertain, get advice from a qualified electrician. To protect your equipment from any irregularities in current, a cost-effective choice is to use surge-protected sockets or extension cables, which blow before your equipment does. If you live in an area of unstable supply, a good idea is to buy an uninterrupted power supply or UPS. This device buys you extra minutes to save your work and close your computer down in the event of a sudden power cut. Any drop in electrical supply will crash your machine instantly with the loss of all your open documents and all your hard work, so it's a risk not worth taking.

Lastly and most importantly, don't put your own health to the bottom of your budget. Buy a good-quality chair with lumber supports and a proper computer desk, which is usually deeper than a domestic table. Make plenty of room to rest your wrists and make a habit of focusing your eyes on a distant object away from your monitor at least once every twenty minutes. Place your monitor at eye level, don't sit in a hunched position and take regular breaks.

Monitor

The most important link in the quality chain is your monitor. Many users unpack, plug in and then forget about their monitors, but it needs to be calibrated before you run your first print out. The purpose of calibration is to ensure that the monitor is giving you a true representation of your image. If monitor brightness and colour remain uncorrected, then you'll get colour-cast prints every time. Professional monitors use a hardware calibrating device, literally a colour temperature meter to make the measurement, but less expensive monitors can be calibrated using a software wizard or step by step. CRT devices need at least 30 minutes to warm up before calibration, but TFTs can be set up immediately. The best one to use is the Adobe Gamma utility, packaged freely with Adobe Photoshop. It works by

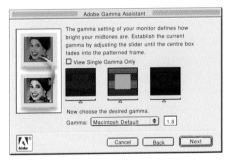

The Adobe Gamma assistant is one of the easiest monitor-calibration utilities to use. Prompted through each stage by step-by-steps, you can save your monitor profile at the end. Adobe Gamma is supplied free with Adobe Photoshop. If you don't know where to look for it, just do Find>Adobe Gamma.

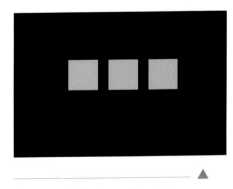

To measure the hardware white point of your monitor, Adobe Gamma presents you with three grey squares. Click on the most neutral.

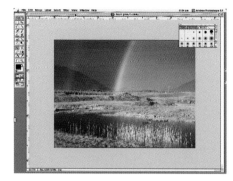

Above shows the same image displayed on three different monitors. Calibration involves fixing a neutral colour balance and midrange contrast, settings which are recalled each time your monitor is switched on. Before correcting any image colour cast, or imbalance caused by the choice of inkjet printing paper, it is vital to make your monitor neutral. Using an uncorrected monitor is like judging colour balance wearing tinted spectacles.

setting the brightness and then each individual RGB colour, leaving a neutral, cast free display. These settings or profiles as they are called, can be saved and read by your computer each time you switch on. Never touch your monitor's external contrast/brightness buttons after calibration, or you'll have to start the whole process off again. Tape them up if they are likely to get moved by mistake. In time, your monitor may attract dust or greasy smears from fingers. Never clean your monitor with any cleaning fluid unless it's been designed for that sole purpose. Like camera lenses and spectacles, a monitor has a delicate surface coating which is easily damaged by touch. Use a clean, soft antistatic cloth for dusting.

Photoshop memory and scratch disk allocation

If you keep getting 'Run out of Memory' errors, you haven't set your machine up properly. After installation, your application needs to be given a proper slice of your computer's RAM resources. Think of RAM like a pie, where each part of your computer's operating system and applications receive a slice proportional to their hungry demands. Photoshop needs to have the biggest piece left over once your operating system has been considered. To work out how much you can allocate, start with the actual RAM you've installed, e.g. 128Mb, then subtract the system software requirements, e.g. 30Mb, leaving 98Mb free for Photoshop.

A scratch disk is a portion of a hard drive which is allocated to Photoshop when RAM memory runs out. When making complex changes or filters, Photoshop needs to call on extra

resources to help out. The scratch disk can be set to any internal drive or partition, but there must be enough spare capacity to cope with the task. If the scratch disk isn't identified, you'll only be permitted to work at a snail's pace, even though you have the drive space. Mac users are recommended to turn off the Virtual Memory function, found under Apple⸱⸱⸱⸱Control Panels⸱⸱⸱⸱Memory as this will conflict with Photoshop's scratch disk system and slow things right down. Many professional workstations have an extra hard drive installed used exclusively as a scratch disk.

For Mac users

To allocate RAM, quit Photoshop and return to the Finder. Get to the Photoshop application folder and click once on its application icon to make it active rather than launch it. From the File menu, choose Get Info⸱⸱⸱⸱Memory. In the Memory Requirements section change the Preferred size to the quantity you worked out earlier. To set up the scratch disk, launch Photoshop then do File⸱⸱⸱⸱Preferences⸱⸱⸱⸱Plug-ins and Scratch Disk. Click on the first drop-down menu and choose your hard drive. Press OK, quit the application, then relaunch.

For Windows PC users

A Windows PC, by default allocates only 50% of free RAM to Photoshop, but you can easily change this. Launch Photoshop, go to Preferences⸱⸱⸱⸱Memory & Image Cache, then move the Used by Photoshop slider until it shows 100% memory allocation. The process for identifying your scratch disk is identical to Mac users, as above. Quit and relaunch.

Colour management

When images are transferred between different hardware devices, software applications and printers, colour change is inevitable. Colour management limits the effects of these changes.

Colour management

Colours never match when data is shared between different devices. To combat this problem a range of software tools have been designed to help you.

You can elect to control a number of different things with colour management tools like a monitor, your workspace, the soft proof and your printer.

Capture devices such as digital cameras and scanners operate in subtly different variations of the RGB colour mode, such as sRGB. These variations are called working spaces and are usually defined by a manufacturer, like the Adobe RGB (1998) workspace or ColorMatchRGB.

When conversion from one workspace to another takes place, i.e. from sRGB to Adobe RGB (1998), actual pixel colour values are changed before the document is opened, in much the same way as making a Colour Balance adjustment.

The Colour Management Module or Engine, like ColorSync or Adobe (ACE) is the software that oversees this conversion process, but you have to configure it to suit your own personal circumstances.

Colour management has always been perceived as a daunting array of technical settings, but in fact it's just like any other photographic process for keeping your images in top-class condition.

Do I need to bother?

If you are working within a closed environment and using the same equipment and software, there are only a few preferences you need to establish and all are highlighted on this page.

If, however, your work is produced for clients or sent to a lab for output, you should agree on a common workspace beforehand.

Setting up your RGB workspace

Some workspaces are less common and smaller in scope than others, so always opt for a broad, universally recognised space such as the Adobe RGB (1998).

You can set up Photoshop to work with Adobe RGB (1998) as its default workspace as follows: Edit····>Color Settings (v5.5 File····>Colour Settings). In the Working spaces drop-down menu, select Adobe RGB (1998), shown below.

Deciding on policies

When handling images that have been created in other workspaces, you can handle them in different ways by choosing different policies. You can either convert to current working space, preserve the embedded profiles, or turn all policies off. A good option is to use the Convert policy. Each time an alien document is imported or pasted, it will be converted to your Adobe RGB (1998) workspace, as shown below:

Tagging your documents

Choose to save your images with the same workspace profile by File····>Save As and check the Embed Color profile box as shown below:

The same image is shown here in three different states of interpretation. Above is an image created in sRGB colour space which was left unconverted when opened in Photoshop 6.0.

This time the policy was changed and the sRGB tagged image was converted into the current working space of Adobe RGB (1998). Notice the very subtle colour change.

Finally, this image is a soft-proof preview after the soft-proof settings were set to reflect the probable results of printing on Epson Archival Matte paper.

Output profiles

At the end of the chain is your printer, which will make the most significant change to your image colour. Here you have three options: set the printer to work within your workspace, use a paper/ink/printer output profile, or use the printer's own colour management. None of these options guarantee a fault-free print. Printer software sometimes includes numerous output profiles to convert a range of different source and display profiles.

Against using Output profiles

Output profiles make invisible corrections to your images and assume that every device will be operating in identical environmental conditions. They also do not guarantee a perfect result.

An alternative to the Output profile approach is to set up a generic profile, make your adjustments manually then save your settings for future use in the printer software itself.

Buying custom profiles

Cone Editions, a leading inkjet research studio in the USA, will make a bespoke output profile for your workstation. After printing out and returning a preset colour chart, they will make a profile which adjusts the colour balance and saturation. Further details are given on page 146.

Paper and printer profiles

For supercritical users, custom profiles can be bought to match your favourite printer with your favourite paper. These profiles take control of any colour and tonal adjustments needed to match your display to the final print. With the Epson 2000P, paper soft-proof profiles are provided free of charge.

Using Printer Colour Management

Only used when no output or destination profile is specified. If you do not have any profiles to work with, or choose not to use profiles, use this option.

Working outside Photoshop

If you choose to edit your images in a non-professional application, don't expect your colours to remain unaffected. Amateur packages like Photoshop Elements do not have any colour-management tools and can make drastic changes to your images.

Key jargon terms

Profile

A profile determines how original pixel colour recipes translate into actual colour appearance, be it on a monitor, scanner or printer.

CMM

Colour Management Module, sometimes called Colour Management Engine is the software tool that instigates the colour translation. ColorSync is an example of a CMM.

Workspace

Both RGB and CMYK colour spaces have variations that account for different devices called profiles.

Display profile

A set of instructions for monitors.

Output profiles

Are also known as destination profiles and are used to translate colours into a ink/paper/printer combination.

Chapter 3
PRINT MEDIA

Paper types

Like a master darkroom craftsman, it's essential to understand the nature of your materials so your choices and decisions are informed by fact as well as feeling.

Paper technology is an expanding and developing subject and despite the concerns over deforestation, there's more paper manufactured nowadays than ever before. With many paper manufacturers keen to benefit from the new market in desktop inkjet printing, there are many products and just as many claims. Yet it's important to know how these products have been manufactured, how long they are likely to last and if they are worth using. Surprisingly, many of the first inkjet papers were nearly impossible to use, a result of overeager manufacturers adapting existing stock, rather than redesigning a necessary new material.

Machine-made papers

At the bottom of the quality scale are the machine-made papers designed for office use and commercial litho printing. Made with pounded wood pulp and a certain amount of recycled paper, alkali agents are used to chemically break down the raw materials. Mass-produced artist's papers contain a more favourable ratio of cotton materials. Techniques in processing pulp are varied, but all use force, heat and chemicals to help separate the fibres. The finished pulp is funnelled through a narrow slot and drawn out across a rolling belt which ensures a continuous web or roll of paper with all the fibres lying in the same direction.

Handmade papers

Greater permanence can be gained from handmade papers, which by their very nature use less chemical agents in their preparation. These papers are generally made from virgin materials including linen rags and cotton and made one sheet at a time. The vatman, as he is known, dips a rectangular sieve (the deckle) into the vat and pulls out a quantity of watery pulp, shaking to mesh the fibres together and drain excess water off. Edges can be modified too with deckled or untrimmed finishes. Archival rag paper is made without the use of any chemical agents likely to contribute to the deterioration of an art image. Both Somerset Velvet Enhanced and Lyson Fine Art share the quality and feel of a handmade material, but with the added advantage of a specially designed surface coating to improve image sharpness.

Recycled papers

Despite the politically correct origins of these materials, recycled papers can be a challenging material to use, if consistency of result is your aim. Recycled papers often have an irregular thickness and little or no grain direction, making it feel 'floppier' and less suitable for large-scale prints. Yet for low-key results with deliberately muted colours, they are an exciting prospect.

Bright white papers will give you very few adjustments to cope with the change from image brightness on screen to print contrast.

Third-world hand-made papers are made in varying thicknesses, even on the same sheet! In addition to these irregularities, some work is needed to 'tweak' the image to print successfully.

Quality writing papers such as Conqueror or Svecia Antiqua will give surprisingly good results. This kind of medium performs best with high-key or light-toned images.

Litho papers are designed for spirit-based printing inks, and are cheap to buy in large quantities. Many paper merchants produce innovative products such as this sample impregnated with bark.

Coatings

For a smoother surface finish, called coated or matt, better papers are impregnated with finely powdered china clay. Matt inkjet paper has a china clay coating, which cracks if you try to fold it. In addition to this, most good artist's papers are produced with an invisible coating called size, which aids the rigidity of paper, and lessens its absorbency. In unsized materials such as blotting paper and copier paper, applied ink bleeds severely into adjoining areas. Sized paper stops this spread occurring and retains sharp detail. For specialist inkjet papers, designed to look like photographic paper, an invisible high-gloss coating is applied which lets ink pass through. Most archival materials use no or only specially devised coatings to extend the lifespan of a print.

Finishes

The surface texture of paper can also be modified in the manufacturing process. Smoothness is achieved by pressing between hot or cold metal rollers, offering a surface capable of holding the maximum amount of detail. Machine-made artist's watercolour papers and commercial litho papers, with a variety of effects such as leather, are generated by running sheets between textured metal rollers to impart a variety of surfaces mimicking the look of handmade papers. Genuine handmade papers derive their texture from the metal mesh used in the sieve, a process also used to make watermarks.

Colour

To cater for the modern-day obsession with brilliant white, bleaching agents are used in the manufacture of cheaper papers, creating unknown reactions with ink. Many papers are dyed to achieve an alternative base colour, such as cream or yellows. Of course a coloured paper base will demand a different approach to image preparation where a much brighter onscreen starting point is required. Any coloured paper beyond a mid-tone won't show highlight areas very well and will play havoc with colour balancing.

Weight and thickness

One of the last remaining battles between imperial and metric measuring systems reigns with paper weight and thickness. Paper weight is either measured in grammes per metre squared (gm2) as in Fabriano 5 250gm or imperially as in Bockingford 250lb. The greater the numbers, the heavier the material will be. Photocopy paper is usually around 80gm. Many inkjet printers will have maximum (and minimum) media thickness guidelines. Yet if you are adventurous, media up to 350gm, fairly rigid card, can be fed through most devices.

Paper sizes

Paper is sold in uniquely coded sizes, as shown below. As a general rule, paper dimensions double with every size increase and halve with every decrease.

Inks

Good-quality inks are an essential ingredient in the desktop printing process. Ink is not something you can ever afford to economise on.

Like the commercial litho process, colour inkjet prints are generated from a small number of colours. Cyan, Magenta and Yellow are used to mix different image colours and Black is used primarily to apply contrast, but also to reduce the need to use (more expensive) colours in dense shadow areas. If you have a background in printing or pre-press, many techniques such as dot compensation and colour manipulation can be applied to inkjet printing and will give you a greater range of tools to use when things go wrong. Inks are a key variable that will cause printing problems if used incorrectly.

CMYK inksets

The basic four-colour inkset can make a moderate job of reproducing delicate colour gradations found in a photographic image, but much better results are achieved when two further colours are included in the cartridge. Photoquality inkjet printers, using CMYK plus light cyan and light magenta, were devised to appeal to the home printing enthusiast as the extra colours mixed a better skin tone. Results from this kind of inkset are much more convincing and have less visible dots appearing in light-toned areas. Inside the cartridge, separate inks are ranked in different reservoirs and are 'called up' during the printing process.

Dyes or pigment?

The printing and textile industries rely on dyes to colour their products, but many dyes are inherently unstable in light. Curtains fade and book covers discolour in sunlight, and the same results occur with inkjet prints. To complicate things further some dyes, such as yellow and magenta, are more unstable than others, leaving the faded print a characteristic cyan colour. A much better way to make stable colour is to use pigments rather than dyes. Paintings from the Renaissance survive due to the quality of pigment used in the artist's oil paints, and only pigment inks should be used for any print that is sold as an artwork or editioned print. Unfortunately, pigments are more expensive than dyes and this is reflected in the price paid by the consumer. When it comes to colour saturation, pigment inks tend to be less vivid than dyes.

Water and solvent-based inks

Most desktop inkjets use water-based inks, but for outdoor display, solvent-based inks avoid problems with the weather. Solvent-based inks are only made for grand-format inkjet printers.

Third-party inks

Desktop inkjets are designed to work best with their own manufacturer's dedicated ink cartridges and paper and will give

Photoquality printers achieve the illusion of photographic colour by using six rather than the standard four inks.

Many early dye-based inks were just not good enough to prevent fading. Some ink and paper combinations could fade to a greeny/cyan colour within a few weeks.

Specialist manufacturers Lyson have been at the forefront of customised inksets and papers. Quad Black inks reproduce cast-free monochrome prints.

Canon manufacture an ink pack which has separate colour pods, so you can replace each colour as it runs out, rather than dump the whole cartridge.

unpredictable results with anything else. Printer software is designed to respond to a predictable supply of colour, and may not be able to fully correct colour imbalance caused by a rogue product. With all the problems associated with colour accuracy, using cheaper inks will only make things more complicated.

Lightfast dye-based inks

Most low-price ink is made with cheaper dyes which are naturally unstable in daylight. Better results are achieved with products claiming an extended lifespan. Epson's own Intellidge ink system replaced their earlier range which was prone to rapid fading within months. Under the author's own tests, prints made with Intellidge inks have yet to visibly fade in under a year. Another alternative is Lyson's Fotonic Archival Colour inksets, which claim a lifespan of 25–30 years. These types of ink should be used for producing prints that need a guaranteed lifespan, e.g. for a portfolio, indoor display or photographic album.

Packs and pods

There's a predicted number of print outs you can achieve from an inkset, but this can be much less than you anticipate if you print images which have a large area of dominant colour. After one colour has been used up, you're left with a useless ink cartridge which will only produce colour-cast prints. To get around this problem, some printer manufacturers have introduced single-colour ink cartridges which can be replaced when the need arises. The better large-format devices responsible for print output running into many metres have individual ink reservoirs, which are usually self-replenishing.

Special inksets

Lyson, a manufacturer long associated with quality printing, manufacturers the innovative Quad Black and Small Gamut Inksets. Using standard four-pod cartridges, the Quad Black set replaces CMYK colour with custom colours of the same tonal value such as black, dark grey, mid-grey and light grey. Colour casts are eliminated from the resulting prints, which have an enhanced tonal quality. Small Gamut inksets use the same principle, but are biased towards a single colours, e.g. brown, for creating photographic printing effects such as sepia toning. The one drawback is that only a limited number of printers are supported by these products.

Microchipped inksets

Unfortunately, some of the latest desktop printers will only work with their own-brand ink cartridges. Epson's latest 2000P has a microchip on the cartridge to prevent third-party inks being used, so if you'd like to try special sets, it's important that you check the compatibility of any new purchase first.

Web link

New materials are constantly being introduced and there are several well-established independent experts evaluating product performance and testing the manufacturers' claims. To keep abreast of the ongoing debate surrounding the archival evaluation of materials check out the informative and impartial website of Wilhelm Imaging Research Inc. on **www.wilhelm-research.com**

Resolution guidelines

It can be difficult to gauge just exactly how much data you need to make a photo-realistic print. But megabytes, pixel dimensions and megapixels all give you the same information: how big you can print.

If you think visually rather than using numbers, as most creative people tend to do, here's a very simple way to keep the mathematics of data size and print size in the background. If you are using an A4 inkjet printer at home, you never need to capture images above 12Mb in size for full A4 photo-realistic colour prints. In fact if you do print out a 24Mb file, then compare it with the 12Mb print: you'll never see the difference.

Actual inkjet resolution

Despite the claims made by inkjet manufacturers about the resolution of their devices, such as 1440 dpi or 2880 dpi, you do not need to match the resolution of your image document to the printer output. The reason for this is simple: the inkjet printer does not match every pixel in your digital image to an individual ink droplet on your print.

Yet another misleading issue is the actual number of ink drops per inch your device sprays onto your paper. The much quoted figure of 1440 dpi does not describe the number of ink droplets dropped on to the paper occupying their own individual territory, but rather the quantity of ink drops dropped together. In practice, this means your printer could drop six different coloured dots (from six different ink pods) exactly on top of each other. If we take this as the starting point

to our calculations, it is possible to work out your printer's true capabilities by dividing its maximum output resolution, e.g. 1440 by the numbers of colours in the ink pods such as 6. This new figure of 240 dpi is much closer to the truth.

Image files take up lots of storage space on your hard disk and removable media, so by having a good understanding of data size in connection to print size means you'll never go in for overkill. You'd never shoot family photographs on a professional 5 x 4 camera, because you just simply don't need that amount of information to make small 6 x 4 prints for your friends. Large image files can also take an age to process and send to your desktop printer, so the leaner your file is, the faster it will print.

Preparing for print

With these figures in mind you now have a good idea of the minimum data requirements for a photo-realistic print. As a general rule, you need 200 pixels of data for every inch of pin-sharp printout. So if you use a digital camera which produces 1800 x 1200 pixel images, you can print them up to 9 x 6 inches on your inkjet.

How big are my pixels?

Surprisingly, pixels do not have a fixed size; you alone dictate their dimensions. You'll recall that three RGB values define a

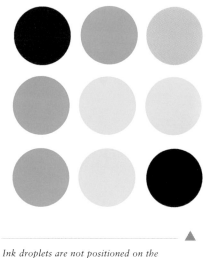

Ink droplets are not positioned on the printing paper in discreet individual spaces, as above.

Instead, each dot overlaps and overprints on top of other dots to give the illusion of photographic colour.

pixel's colour recipe, but it's in the Image Size dialogue box where you define the size. Any pixel could be an inch square in size, but like a crude mosaic, it would not create a photographic illusion. The bigger your pixels are, the more blocky and unrealistic your printout will look. The smaller your pixels are the more your print will look like a photographic print. By default all digital cameras output their images at 72 dpi, but if you make the pixels smaller, such as 200 dpi, they will become invisible on your printout.

How many pixels do I have?

If you are acquiring your images by scanning, it may not be apparent from the software just how many pixels you have. To get this information, check in the Image---⟩Image Size dialogue box.

Image modes and data size

Grayscale images are only a third of the data size of RGBs. With the same pixel dimensions and print size, these files only need a third of the data. If you convert an RGB into a Grayscale, the document will shrink to a third of its former size. CMYK images are four times the size of Grayscale as they have an extra colour channel.

36-bit and 48-bit colour images

Many recent capture devices create images with billion colour palettes, such as 36 and 48 bit. These larger palettes create images with enormous file sizes, which need to be scaled back to 24-bit for printing out because output devices can't cope with anything more. Always refer to the 24-bit size of your file when making a judgement.

Enlarging and reducing

Of course you can always add new pixels to your image by a process called resampling or interpolation. Yet, like a photocopier, your images will get bigger but will lose sharpness along the way. Original captured pixel data will give you pin-sharp photographic prints and anything else will be a compromise.

Output to other devices

If you want to submit images for magazine or book publication or output to a dye-sublimation device you'll need to package your images at 300 dpi. Higher-resolution output devices can cope with higher-resolution image files and results will look disappointing if original files are not prepared to take maximum advantage.

Data size and print size calculator

If you find it difficult to work out how much data you need to make a particular print size, use this simple guide to work it out. If you keep your pixel dimensions fixed and avoid resampling, you can work out how big your prints can be, even from the data size.

Image mode	Data size	Mega pixel size	Pixel dimensions	Inkjet print size (200 ppi)	Dye-sub print size (300 ppi)
RGB COLOUR (standard 24-bit)	24Mb	8M	3450 x 2450	12.5 x 15 inches or 31 x 44cm or A3+	11.5 x 8 inches or 21 x 29cm or A4
	12Mb	4.1M	2350 x 1770	12 x 8.5 inches or 30 x 22.4cm or A4+	8 x 6 inches or 20 x 15cm or A5
	6Mb	2.1M	1800 x 1200	9 x 6 inches or 22 x 15cm or A5+	6 x 4 inches or 15 x 1 0cm or A6
	2.25Mb	n/a	1024 x 768	5 x 4 inches or 13 x 9.75cm	3.5 x 2.5 inches or 8.6 x 6.5cm
	900k	n/a	640 x 480	3 x 2.5 inches or 8 x 6cm	2x1.5 inches or 5.4 x 4cm
GRAYSCALE (standard 8-bit)	8Mb	n/a	3450 x 2450	12.5 x 15 inches or 31 x 44cm or A3+	11.5 x 8 inches or 21 x 29cm or A4
	4Mb	n/a	2350 x 1770	12 x 8.5 inches or 30 x 22.4cm or A4+	8 x 6 inches or 20 x 15cm or A5
	2Mb	n/a	1800 x 1200	9 x 6 inches or 22 x 15cm or A5+	6 x 4 inches or 15 x 10cm or A6
	750k	n/a	1024 x 768	5 x 4 inches or 13 x 9.75cm	3.5 x 2.5 inches or 8.6 x 6.5cm
	300k	n/a	640 x 480	3 x 2.5 inches or 8 x 6cm	2 x 1.5 inches or 5.4 x 4cm

Chapter 4

PRINTER CONTROL

····⟩ Printer limitations

····⟩ Calibrating your printer

····⟩ Controlling printer software

····⟩ Testing different media

Printer software decoded

The printer software adjusts to the dynamic range of each type of media using simple user-defined controls.

Media setting

It is very important to match the type of paper you intend to use with the nearest equivalent Paper Setting, as this determines how much ink is sprayed on your paper.

If you choose the wrong paper setting, you will end up with a heavy and soggy result. Surprisingly, choice of print media will affect the colour balance of your final print.

Printer resolution

Most printers can be set to work in lower-quality mode for producing roughs or proof prints. A printer resolution of 360 dpi sprays fewer dots on the printing paper, regardless of your image resolution. Results will be grainy, with obvious spaces between the dots. Best photo quality is achieved with 1440 or 2880 dpi.

Quality v speed

Never use Speed setting for photographic quality printouts.

Colour space and management

In the Space drop-down menu you can set the printer to work within the same colour workspace as your application, such as Adobe RGB (1998). Although the printer colour-management option does give excellent results, this should be deselected if you have selected a custom output profile from the Space drop down menu above.

Error Diffusion and Fine Dithering

Halftoning is a method of mimicking continuous tone colour using limited inks. Error Diffusion and Fine Dithering are two different halftoning methods. Error Diffusion creates a random pattern of dots to mimic subtle colour distribution and is the best method for reproducing photographic images.

Fine Dithering allocates dots in a uniform pattern and is best used for printing graphics and solid colour areas.

In certain printer dialogue boxes you may be presented with halftoning methods described as Photo or High Quality. Only use this to print out plain text.

Auto modes

Automatic and PhotoEnhance are preset modes that apply unseen corrections to your files. Never use these, unless you want to bypass all your careful Photoshop adjustment work. PhotoEnhance modes have been developed for amateur users without access to sophisticated imaging software.

Custom mode

Custom is the only mode you should select, as it allows you to drive the printer at its highest quality without adjusting your image data. Click on the Advanced drop-down to see all the Custom options.

Microweave

To help reduce the visible effects of banding use Microweave or Super Microweave if available.

Ink

By choosing black ink only, you effectively reduce the printer resolution. Never choose black ink to print grayscale; your prints will show the signs of ink droplets.

Soft-proofing with profiles

If you are a Photoshop 6.0 user, you can get an accurate preview of your expected print on your monitor.

Another layer of previsualising your expected printout is to use Photoshop's soft-proofing function. Loaded with a set of profiles to match common input, display and output devices, it also supports media profiles of the printer you are connected to.

The function is intended primarily for commercial printers to visualise individual printing plates and final ink proofs before committing to expensive film separation, but it can be used for desktop inkjet output too.

With the Epson 2000P pigment printer for instance, Photoshop gives you four different paper profiles so you can see just how your image will appear on paper.

Above left is an image in normal mode, but above right is the same image with View----}Proof Colours turned on. Notice the slight loss of saturation and a duller white point, both a better indication of the final result compared to the monitor display.

To set up a custom view proof, do the following:

Step 1
Go to View----}Proof Setup----}Custom and check the Preview button so you can see the change as it happens. ----}

Step 2
In the Profile drop-down, pick the colour profile that matches your intended image destination, in this case the Epson 2000p with Photo-Weight Glossy paper. ----}

Step 3
Turn off Preserve Colour Numbers and choose Perceptual as your rendering intent. This best simulates how your image colours are mapped from the document space to the proof space, as shown in the illustration below.

Step 4
Finally, select Simulate Paper White, to get an indication of the difference between your monitor white point and the base white colour of your printing paper.

The acid test, of course is to compare your final print to the onscreen soft proof!

Setting up your printer
If you do decide to use printer profiles for proofing, it's essential that you configure your printer software dialogue box as shown below.

From the Source Space drop-down retrieve your document working space and your Proof Setup profile. In the Print space drop-down, choose Same as Source.

Buying custom profiles
If you are a Photoshop 6.0 user, you can buy purpose-made profiles for nearly every printer and paper combination. See Profile Suppliers on page 146.

Calibrating your printer

With your colour-management system in place, you can now start testing how ink and paper respond to each other. If the shadow areas in your digital prints start increasing, then you'll need to make some adjustments.

Unlike photographic paper, inkjet prints can't separate tone in heavy shadow areas, printing solid black after about 94%. This has the effect of 'spreading' your black shadows, much like infectious lith development. You can make a simple calibration test to identify the extent of the problem before testing individual papers.

Step 1

Create a new RGB document at 200 ppi, at a size that matches the size of your destination print paper. Use the Grid to lay out four identical vertical wedges, one for each CMYK colour.

Next use your Rectangular Marquee tool to draw and fill each step with a precise colour value. In the Color Picker dialogue box, type the colour value directly into the text box. Make your wedge run from 10–90 in 10% increments, and from 0–10 and 90–100 in 2% steps, as shown below.

Step 2

Save your wedge as a TIFF and print it out onto the desired paper. Use the highest-quality printer settings and make a note of them. Don't enlarge or reduce the size of your printout. Inspect the test wedge at the shadow end of the Black ink scale and make a note of the last visibly separated step. In most examples it's around 94%. Any black tone after this will 'fill in', so your print will not look as tonally subtle as the image on your monitor display.

Step 3

Open the image you want to print and select Window⋯Show Info. Float your cursor over the shadow areas and see if the K (black) Info readout exceeds your paper's range, e.g. 94%. There will be areas of your image that exceed this value.

Step 4

Next, you need to modify your image to prevent shadow gain. Remember Levels uses the 0–255 and Curves uses the 0–100% scale, so you will need to translate your findings.

Using Levels for RGB and Grayscale, drag the shadow slider in the Output scale until 12 appears in the Output Levels text box. This is based on 2.5 per 1% increment.

90%
92%
94%
96%
98%
100%

92%
94%
96%
98%
100%

Step 5

Alternatively, if you prefer to use Curves, move the shadow point until the Output value reaches 94%.

Practical applications

Now that you have recognised the shadow limits of one kind of paper and ink with one kind of printer, you can save your results for the future.

Approach 1

Armed with this information, you can apply these changes manually on each and every image, or

Approach 2

Save your Levels and Curves settings for each paper, then Load them on each subsequent image just before printing out, or

Approach 3

Assemble this information with colour-balance and saturation test results into an Action file.

The Test wedge (right)

Surprisingly, each different colour stops separating at different points in the scale.

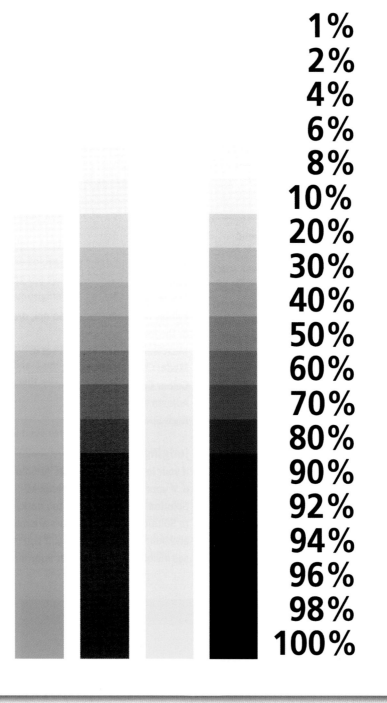

1%
2%
4%
6%
8%
10%
20%
30%
40%
50%
60%
70%
80%
90%
92%
94%
96%
98%
100%

Making profiles in Photoshop

If you don't want to rely on your printer software controls, you can assemble a string of sophisticated image adjustments into a Photoshop Action file.

Action and droplet files

All Photoshop commands and adjustments, such as those used to correct contrast, colour balance and saturation, can be grouped together to form a kind of profile.

As a result of testing and printing images onto your favourite paper, you will soon arrive at a set of commands that will achieve predictable and hopefully good-quality results.

Actions and droplet files are Photoshop's way of recording and playing back a set of instructions, which can be saved and applied to single images or batches of images.

Commands to include

You can choose to include all or just some of the following commands to match an image to the paper/ink/printer combination:
Levels to correct brightness.
Curves (or Levels) to reduce shadow point.
Colour Balance to correct colour casts.
Hue/Saturation to increase colour values.
Unsharp Mask to tweak print sharpness.
Print Options to select printer colour space.

Commands you can't include

Any choices you make in the printer software dialogue, such as printer resolution and media type, can't be included.

Creating Action files

Once you have established a proven sequence of adjustments for your output, write them down on a piece of paper. You will need to refer to the precise adjustments when recording your action.

Step 1

Open an image in Photoshop. Next open your Actions palette and from the tiny pop-out menu (top right) choose New Set. This makes a folder to store all related actions, so give this the name of your printer. Next repeat this but choose New Action and name it with the paper type.

Step 2

Click on Record and replay the exact string of commands, in the same order and with the same level of adjustment.

Step 3

Once complete, press the tiny black Stop square, found at the bottom left of the Actions palette.

Step 4

Close your image and open another one, then click on the action you've just created in the Actions palette. Press the Play triangle and watch your image undergo the rapid sequence of auto processing.

Setting up your printer

Make sure your printer settings remain unchanged, as any modification will alter your results. Keep a record of your settings to hand.

Tips: Create different actions for different image modes like grayscale and RGB. Make different actions for different sources, such as images from your digital camera and your scanner.

Why use profiles?

Even if you are the most die-hard, anti-technical image maker, when it comes to using output profiles, you probably fit into one of the following three categories.

Intuitive user

Many digital photographers enjoy the push-and-pull nature of making hand-crafted prints. Interpreting the original file, testing and responding with corrections, typifies a person unconcerned with background theoretical issues.

You probably think now...

I've never even heard of profiles.

Reasons not to bother

The very idea of using scientific settings to modify colours takes all the pleasure out of a personal approach. A cast-free neutral print is not an issue for me.

In the next five minutes

If you can spare five minutes before starting off, calibrate your monitor (pg 34) and set up your RGB workspace to Adobe RGB (1998). It will make an instant difference to your work.

In a spare half-day in the future

When your creative powers are resting, spend a little time fine tuning your workstation and printer. Experiment with different printer settings and different printer workspaces and remember the best ones for your next session.

Disappointed user

You are an experienced photographer but relatively new to digital printing. Good prints come out at random intervals, more by luck than design. Your high investment in new equipment does not yet deliver the goods, but you know there's probably a secret you don't know about.

You probably think now...

I've heard of profiles, but I can't really grasp where you get them, where they go and how they work.

Reasons not to bother

The process sounds like opening a can of worms and I'll probably make things worse rather than better.

In the next five minutes

Have a short think about the amount of paper you have already wasted, then calibrate your monitor, set up your workspace, and match this in the Print Options.

In a spare half-day in the future

Start developing your own home-made profiles for different paper types using Photoshop or the printer software. Your success rate will improve instantly.

Sceptical user

You are dealing with images from a number of changeable sources. You also have to output on different media for different clients. Your workstation is well used and you are confident in your ability to make technically excellent images, but printing always falls short of your expectations.

You probably think now...

Profiles are not going to solve the idiosyncrasies of my workstation and I never rely on auto functions.

Reasons not to bother

Can't afford the time, the cost of buying profiles and I understand enough about Photoshop already to make the corrections I need to do manually.

In the next five minutes

Check your current colour-management strategy. Is it watertight? Are there any conflicting settings? Finally, recalibrate your monitor.

In a spare half-day in the future

Install some free profiles and see if they make a difference. Develop your own profiles into Action files for time saving and consistency.

Chapter 5
PHOTOSHOP CONTROL

Contrast and brightness

Manipulating tone is a hard-won skill acquired by darkroom experts over many years. Software tools and techniques can appear alien at first, but they extend the creative process and are identical for both colour and black and white images.

The Levels dialogue box

Despite the attraction of quickfix tools like Auto Contrast, Auto Levels and Brightness/Contrast, using Levels manually will give you precision control over your image.

In the centre of the dialogue box is the Input Levels Histogram and three text boxes for highlight (255) midtone (100) and shadow (0). These tools are used to modify your image onscreen.

At the bottom is the Output levels slider and two text boxes: (0) for shadow and (255) for highlight. This tool is only if you want to compress the tonal range of your image for printing out.

Three dropper tools are provided for you to set either Highlight, Shadow or Midtone manually by clicking on a part of your image (outside the dialogue box). You can save and store Levels settings and reload them onto other images by pressing LOAD.

Understanding the histogram

This useful graph shows the exact distribution of pixels along the horizontal 0–255 scale, together with the quantity of pixels shown vertically. Rather than relying on an arbitrary visual judgment, which we make in the darkroom, histograms present precise information in an easy graphic manner. Along the baseline are three triangular sliders, the black one (far left) represents the shadow, the grey one (in the middle) is the midtone, sometimes referred to as the gamma slider, and the white one (far right) is the highlight.

Despite the scientific appearance of the histogram, it gives you the exact distribution of your pixels and from this, rather than the image itself, you can tell if it's overexposed, underexposed, low or high contrast. To match these scenarios there are recognisable graph shapes. Once you've spotted the problem, solving it is even easier.

Adjusting brightness

Brightness in the digital world matches 'exposure' in traditional photography. In the darkroom, you can correct underexposed and overexposed negatives by reducing and increasing print exposure time accordingly to arrive a balanced print which shows off all its detail.

Using the Levels mid-tone slider, it is possible to make the image lighter by sliding to the left or make it darker by sliding to the right. This process leaves both highlights and shadow areas unaffected, so you won't see burn-outs or fill-ins.

You can also make the adjustment by typing in the centre text box, although this is less intuitive. When adjusting images to output on different printing papers, the Levels midtone slider is the ideal tool to make simple adjustments to fit paper stock. If you go too far with your slider, press ALT+ Reset in the dialogue box.

Setting White and Black Points – 1
This image is low contrast, scanned from a thin negative. There are no strong blacks or clean white, just muddy greys. ┄┄⟩

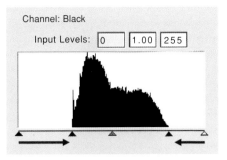

Setting White and Black Points – 2
In Levels, see the pixels ranged around the midtones. Slide highlight and shadow triangles to the nearest column. ┄┄⟩

Setting White and Black Points – 3
Both points are now set and contrast is restored. If you open Levels again, the graph will have changed shape.

Increasing brightness – 1
This image is too dark, scanned from a heavy print. Little detail is present because the shadows block it out. ┄┄⟩

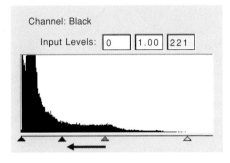

Increasing brightness – 2
The Levels graph shows pixels ranged around the shadows. Move the midtone to the left until your image looks better. ┄┄⟩

Increasing brightness – 3
Detail now miraculously reappears! With extreme cases, be careful to avoid burning out your highlights.

Decreasing brightness – 1
This image is too light, scanned from a washed-out print. There's little depth to describe the 3D subject. ┄┄⟩

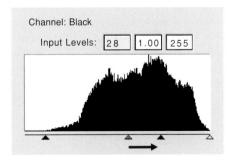

Decreasing brightness – 2
The Levels graph leans over to the highlight side. Move the midtone to the right, but be wary of going too far. ┄┄⟩

Decreasing brightness – 3
Only a slight move of the slider has caused this change. The statue now looks more solid and the image more descriptive.

Using Curves

Where Levels lets you control three points of tone, Curves allows up to 15. By pushing or pulling the line, you can brighten or darken a very specific part of your image.

The Curves dialogue box

Instead of a histogram, the diagonal line in the Curves palette lets you change the brightness of a very narrow tonal area, leaving other parts of the image unaffected. In practice this is useful for reducing dense shadow areas or brightening up midtones that become flat after printing out.

In RGB mode, highlights are found in the bottom-left corner, shadows at top-right and increments measured on a 0–255 scale. In both CMYK and Grayscale, highlight and shadow positions are reversed and a 0–100% scale operates.

Separate Curves exist for different channels in all colour modes. For simple adjustments, work on the composite channel, called RGB or CMYK in the drop-down menu. In a Grayscale image, there's only one channel, black.

Understanding RGB Curves

The midpoint of the diagonal line is your image midtone, so to make this lighter or darker, simply push upwards or pull downwards. By clicking onto any part of the line, you are identifying an area for change.

To stop other areas from changing too, simply click a point either side. These new points will lock the curve and prevent it from moving with your new adjustment. If you go too far, your colours will reverse and look solarised. Only a tiny movement may be necessary to lift an area of your image.

Reducing the value of the shadow areas is a useful correction when printing to unconventional media, as a full black may be reproduced after only 85%. In this case, move the black point until the Output box displays the right figure.

Selecting tone from your image

If you can't guess which bit of the Curve corresponds to the problem area in your image, you can move outside the dialogue box and select it directly.

As the dropper tool appears, position it over the problem area then Ctrl + Click (Windows) or Command + Click (Mac). A point will now be placed on your Curve, ready for you to move.

Rather than tugging at the points and seeing immediate and often drastic change, use the Arrow keys on your keyboard to slowly lighten (Up arrow) or darken (Down arrow).

If you click more than one point on the curve, the black dot denotes the active point.

If you enter too many points or adjustments, just Option + Reset to start again.

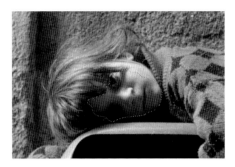

Lighten a selection area – 1

Draw a selection around the area you want to change and feather it with 5 pixels. This face is too dark and will lose even more detail when printed. ····⫸

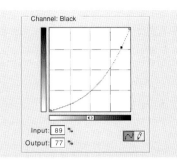

Lighten a selection area – 2

Click-select a curve point from your image, from the near shadow area of your selection. Pull the point down until the area lightens, without going too far. ····⫸

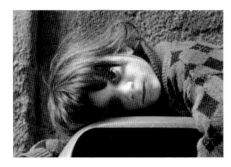

Lighten a selection area – 3

Press Okay and view the results. The face has now brightened without changing any surrounding image areas.

Increasing contrast – 1

Even if your image has a white and black point, you can increase contrast by creating a curve that lifts everything in between. ····⫸

Increasing contrast – 2

On the composite channel, make a curve as above. Carefully push each point upwards until your image gains a bit of punch. ····⫸

Increasing contrast – 3

The final result shows a much more lively image with less muddy colours.

Curves colour control – 1

Difficult casts, like this one in white highlights, can be removed easily. ····⫸

Curves colour control – 2

In the Curves dialogue, click on the Auto button. ····⫸

Curves colour control – 3

The colour imbalance will now be removed.

Colour balance

After brightness has been adjusted, the next step is to colour balance your image. There are many reasons why colour casts appear, but the hardest task is to identify the right course of action.

The Colour Wheel

In order to correct colour casts it is necessary to understand a fundamental rule. Casts can only be removed by increasing the value of its opposite colour. The colour wheel shows the three primary colours (RGB) and three secondaries (CMY) used in this process. To remove a blue cast, often present on daylight transparencies shot under cloud cover, yellow is increased to compensate.

Just as dark and heavy images prevent fine detail from becoming visible, so the slightest colour cast will dull down other non-related colours and lead to lower image quality.

In addition to neutralising, colour balancing can be used to warm up or cool down an image, just like using conventional camera filters.

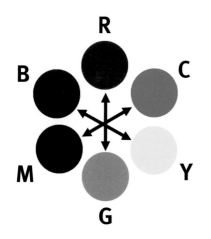

Colour Balance dialogue

This simple tool to correct colour balance is set to Midtones by default. Most colour casts can be removed by using the midtone slider, and the results can be viewed in the image, behind the dialogue box, in real time.

Occasionally a cast may occur in the highlight areas, especially if the original image was shot under artificial or mixed lighting or with the wrong white balance setting on a digital camera.

Colour Balance Adjustment layer

If you are unsure about committing to a correction, do Layer ····> New ····> Adjustment Layer ····> Colour Balance. This will give you the same dialogue, but will 'float' your settings as a layer and allow you to return and modify.

Tip: If you go too far with your corrections, press Alt+Reset (appearing in place of Cancel in the dialogue box).

Variations dialogue

If you are not confident about detecting a cast, do Image ····> Adjust ····> Variations. This dialogue box will present your image in the centre of a ring around, showing the effects of adding other colours.

By clicking on the square that looks most neutral, corrections are made in a visual way and the larger your monitor, the larger this dialogue will be. The intensity of the changes can be modified too, by using the Fine to Coarse slider.

Rarely will more than one colour cast dominate your image, but if you do go too far, click on the Original image (at the top left of the dialogue) and you'll be returned to your starting point.

Causes of colour casts

Rarely are photographic images cast-free because film and digital sensors are designed to work within a much narrower range than the human eye. All light, natural and artificial, can be measured on a colour temperature scale, resulting in daylight balanced film and digital cameras with different white balance settings for tungsten, fluorescent and flash.

The problem with these settings is they are only a starting point and will not cope with environmental conditions present on your shoot.

The main influences on colour imbalance are as follows.

Time of day

Natural daylight in the morning is bluer, but towards evening is redder. Shooting under cloud cover or dull conditions can often leave a cold or bluish cast in your images. Using fill-flash outdoors can present you with the problem of balancing the flash-lit subject with the ambient-lit background.

Local colour

Natural canopies, like a leafy tree, will act like a giant green filter, making any images shot underneath take on a disappointing green cast. Even window glass will filter daylight when shooting indoors.

Mixed lighting

Inevitably your subject may present itself lit by both natural and artificial sources. In this case, colour-balance adjustments can be made within a selection area.

Identifying casts

Midtone neutrals are the easiest place to spot colour casts. The example below shows a landscape image that has had +50 of all six colours added to it. In the centre is an uncorrected portion and the casts are best observed in the the neutral grey sky. No effect can be seen in the strip of white between the image and the solid blocks of colour at the top.

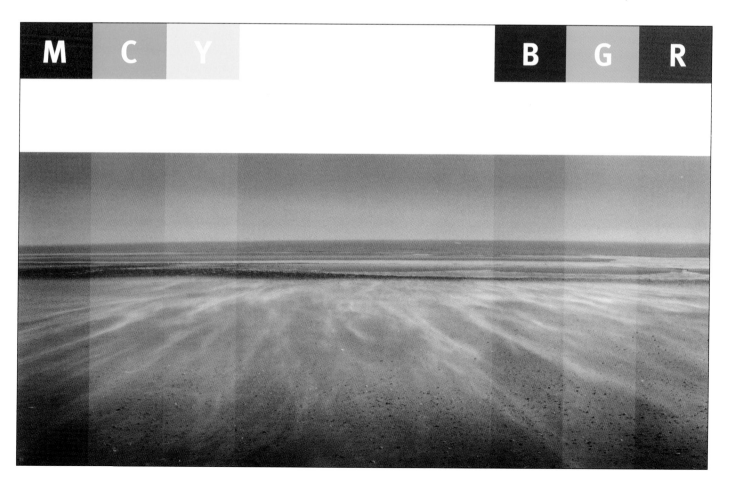

Colour gamut

Gamut defines the limited colour range of any input or output device. Unfortunately, CMYK inkjets can't reproduce colours as vividly as we see them on an RGB monitor.

RGB v CMYK

The biggest drawback with desktop digital printing comes from gamut problems. Above shows the difference between the CMYK colour space (inside the blue shape) compared to the RGB space (inside the red shape). The entire circle represents the range of our colour perception, far greater than all colour spaces put together.

Put simply, what you see on screen may not translate to print, because CMYK can't mix such saturated values. Certain RGB colours are more problematic than others, such as saturated blues, and you can't get an accurate idea of CMYK colours such as pure cyan or yellow on an RGB monitor.

Stay in RGB as this is a device-independent colour space, not controlled by target ink colours or even monitors.

No problems occur in Grayscale, but there can be an issue with duotones if you specify Pantones as your ink colours.

Warning devices

Before you start analysing printouts for accuracy of colour, you need to make sure the image you've sent to print has not exceeded the gamut for that device.

Colour Picker

There are many different methods for keeping gamut disappointments at bay, but the simplest one to watch for is the warning triangle in your colour picker. Any time a colour is picked for retouching, or when setting a text colour, watch for the warning triangle that appears to the right of your chosen hue.

Before *After*

If you do pick a problem colour, usually one at the top of its saturation range, click on the triangle and your colour selection will be changed to the nearest printable value.

CMYK preview for v5.5 users

When working on RGB images destined for CMYK output, use the CMYK Preview function. Your colour mode won't change, but the monitor will present you with a constant simulation of the final conversion. To turn this on do View ····▸ Preview ····▸ CMYK.

CMYK preview for v6.0 users

An identical CMYK preview function is offered in v6.0, but found under the View····▸Proof Colours.

Soft-proofing

Photoshop v6.0 includes many more advanced preview functions than previous Incarnations, including customised soft-proofing. Like the CMYK preview, you can preview exactly how your image is likely to print on certain papers. For more details, refer to page 51.

Gamut Warning

The most sophisticated control to use is the Gamut Warning found in View ····▸Gamut Warning or by the shortcut Shift+Command+Y. You can leave the warning on all the time, or just check it on and off regularly during work in progress.

The Warning applies a marker colour, grey by default, to any image colours that lie outside the CMYK range. When printed these colours will frequently look less saturated and could have a negative impact on your image.

All colours will be identified with the same grey marker, but there may be more than just one to deal with.

Gamut Warning is unavailable in Duotone mode, so if you use bright colours you will have to convert to RGB before checking.

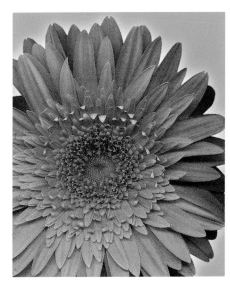

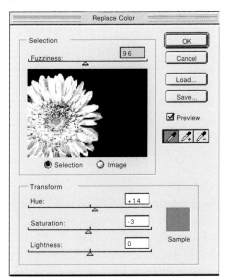

Changing out of gamut colours – 1

This image looked very vivid on screen, but after the Gamut Warning was turned on, the very same vivid colours are identified as out of gamut. Keep the Warning switched on. ⸳⸳⸳⸳⟩

Changing out of gamut colours – 2

Go to Image⸳⸳⸳⟩Adjust⸳⸳⸳⟩Replace Colour. Place the dropper tool on the image and sample the dominant grey warning colour. Next, use the Fuzziness slider to grow your selection, denoted by the white areas in the b&w preview image. ⸳⸳⸳⸳⟩

Changing out of gamut colours – 3

Next, move the Saturation slider to the left and decrease the intensity of the problem colour area. You should notice the grey warning colour start to disappear. ⸳⸳⸳⟩

Changing out of gamut colours – 4

Now the saturation has lowered, you may want to bump up the colours by choosing another hue. ⸳⸳⟩

Changing out of gamut colours – 5

Other hues can lie inside the gamut, so move the Hue slider until it improves. Too far and the grey warning will reappear. ⸳⸳⸳⟩

Changing out of gamut colours – 6

The end point is a compromise, but not one that sacrificed bright colours for a duller version.

Image sharpness

Like a final focus on the enlarger before exposing a sheet of paper, sharpening a digital image will dramatically improve the quality of your final printout.

Most digital images need sharpening, especially those taken with a digital camera. You can't disguise a badly focused image with digital sharpening, but you can improve a near-miss.

All sharpening really does is to improve pixel contrast at the edge of shapes, where a loss of sharpness is most visible.

Photoshop presents three sharpening filters, but the only one worth using is the Unsharp Mask Filter (USM). Named after a traditional film process, this filter gives you precise control over the extent and visual effects of sharpening. In the dialogue box (above) there are three sliders: Amount, Radius and Threshold.

The USM Tools

The Amount slider gives you the ability to define an increase in pixel contrast; most images will lie between 50 and 150%. Radius defines the number of edge-adjoining pixels you want to work on. Finally, Threshold defines how the filter detects edge pixels.

USM starting point

An effective starting point for sharpening is Amount 100%, Radius 1 pixel and Threshold 1 level.

Sharpening guidelines

The golden rule of sharpening is to leave it to the very last moment before printing out. As USM may introduce noise or other artifacts, any tone or colour manipulation that occurs after this may look more visible. Overcooking an image occurs when you simply apply too many adjustments, leaving a pixellated mess.

Using LAB mode

A useful technique to prevent colour-fringed artifacts appearing in highlight areas is to convert to LAB mode beforehand. In the Channels palette, select the Lightness channel, where no colour information is stored, and apply the USM to this channel only. Examine the results and notice a much less noisy result.

Kodak Photo CD

If you've been disappointed by the apparent lack of sharpness from Photo CD files, it is because a soft image allows for greater compression rates. All Photo CD images will benefit from USM.

Internet-based minilabs

The latest revolution in digital printing is the Internet minilab, where digital files are emailed, printed and returned through the post. Sophisticated minilab machines include an automatic USM sequence before sending to print, so you may not need to apply it yourself. Or you may find your intentionally delicate out-of-focus images have been sharpened without your consent!

Print sharpness

Despite the careful application of USM, some print media will not hold a sharp ink dot without spreading like blotting paper. Uncoated media may require a more vigorous amount of USM to compensate.

Batch processing

Once you have settled into using your own digital camera and scanning equipment, you will find that USM adjustments will remain constant for each device. To avoid repetitive processing, make an Action file to apply your USM to a folder of images automatically.

Unsharpened

Amount 50 Radius 1 Threshold 1

Amount 100 Radius 1 Threshold 1

Amount 200 Radius 1 Threshold 1

Amount 100 Radius 3 Threshold 1

Amount 100 Radius 6 Threshold 1

Amount 200 Radius 12 Threshold 1

Amount 200 Radius 20 Threshold 1

Amount 400 Radius 20 Threshold 1

Enlarging and resampling

You can't convert a low-resolution pixel image into a high-quality printout, because original detail is not there in the first place. Interpolation and resampling all involve one process: removing or slotting new pixels between original ones.

Any time the pixel dimensions of a digital image are scaled up or down to fit an output size, pixels are added or thrown away. Resampling is the overall term applied to this change, with interpolation describing the enlarging process and down-sampling referring to reduction.

Many scanning and digital camera sensor software packages use an interpolation routine to improve the apparent resolution of a digital image, but at the expense of pin-sharp quality.

This process can be likened to a 35mm original duped onto 6 x 9 cm film stock, where enlarging the apparent size of your original doesn't suddenly gain more detail, sharpness or image quality, but, in fact, the reverse.

There will always be occasions when resampling is unavoidable, but some general principles will prevent severe loss of quality.

When to do it
Resampling is best undertaken on unsharpened and unprocessed images, i.e. those which have not gone through USM or not likely to show even minute signs of pixel artifacts. These error pixel patches will only be made more evident as a by-product of the process. You are unlikely to see any visible loss of quality with small scale resizing, such as a 10% increase.

Transforming and scaling
Even during work in progress, interpolation and down-sampling takes place each time you transform or scale a selection or layer. Remember the same principles apply: you can't expect pin-sharp results if you scale up a tiny element of your image.

Setting the Interpolation method
There are three resampling methods used in Adobe Photoshop: Nearest Neighbour, Bilinear and Bicubic. Nearest Neighbour is the fastest process, but has the lowest quality. Never use this on photographic images, but only with hard-edged graphics like screenshots. Bicubic is the best process to use for upscaling as it bases new pixel colour on a block of adjacent pixels. In the Preferences menu, choose General and select Bicubic.

Text and vector elements
If you have an image with type layers, don't flatten it before resampling. Type and vector line layers automatically adjust to the image resolution, provided they remain unrendered, i.e. not converted to pixels. If they are rendered or flattened, they will appear jaggy or staircased after enlarging or reducing. Photoshop 6.0 has a range of new vector tools to help line work print sharp even after a change in resolution.

Low-quality JPEGS
There are certain types of image file that just won't resize because of innate defects. Low-quality JPEGs, with very visible block damage, will not enlarge as the visible imperfections will only become more evident.

Noisy images produced by high ISO settings on a digital camera will also show increased signs after enlarging, although this can be reduced by a noise-reduction filter.

Scaling in stages
One school of thought concerning resampling advocates a gradual step-by-step method, accompanied by small amounts of USM filtering. Instead of increasing the pixel dimensions by 50% in one command, the process is applied in five 10% increments with a low USM filtering such as 20 A, 1R 1T.

Making montage images
If you are assembling different source images in a montage, they are bound to be of varying dimensions. A good approach is to make sure you scan the largest originals available and all at higher Input resolution than normal, e.g. 400 dpi. Scaling down high-resolution images creates less visible damage than enlarging lower-resolution images.

Over-enlarged
If you get an unfocused print like this, you have over-enlarged your original file. Reshoot, rescan or reprint smaller.

Over-reduced
One-step drastic reductions in pixel dimensions can result in staircasing, particularly visible in graphic shapes.

Bad original to start with
You can't elicit detail from low-res files. This 640 x 480 image can't be rescued and USM makes it look even worse.

Enlarging – 1
Open Image Size and click in the Resample and Constrain Proportions check box. Select Bicubic from the drop-down menu. ⟶

Enlarging – 2
In the Pixel Dimension Width box, increase your image by by 10% or so, taking this example from original 1800 to 2000. ⟶

Enlarging – 3
After each 10% increase, apply a very slight USM to sharpen your result. Repeat stages 1–3 until you get to the right size.

Pixel bitmap
Close up, pixel images are arranged in a mosaic-like grid. ⟶

Enlarging
To make the pixel bitmap bigger, new pixels are slotted in between originals, but with estimated colour values.

Reducing
To make the bitmap smaller, columns of pixels are removed, leaving originals to move closer to one other.

Burning in and dodging

If you've spent any time in the darkroom, you'll be well versed in the art of burning and dodging your prints to create subtle emphasis effects. In Photoshop, you can exercise all your craft skill control, without the need for scrappy bits of card or blobs of blue tack.

The starting point is a landscape image which needs attention to both sky and ground areas. By burning in both parts, the image will better convey the drama of a brooding Irish mountain scene.

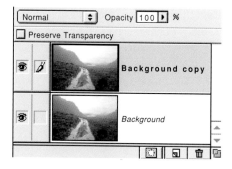

Step 1 – Burning in

Open your image and then do Layer····▷Duplicate Layer, just in case you make a mistake. Work on this Background Copy layer only. If you go too far, then simply drag the Duplicate layer into the wastebasket and start again.

Step 2

Pick the lasso tool and check it doesn't have a preset feather value. Make a rough selection around the area you want to darken down and make sure you close the selection loop. Don't worry about being too accurate at this stage.

Step 3

Now soften the selection edge by doing Select····▷Feather. Feathering has the effect of changing your sharp-edged selection to a diffused edge that blends easily into the surrounding area. Make it a 100-pixel feather radius. If you find the moving selection lines distracting you can hide them by doing Cntrl+H on your keyboard (Command+H for Mac users). But don't forget to Select····▷Deselect when finished.

Step 4

Now to darken this area down choose Image····▷Adjust····▷Brightness/Contrast Start with –30 Brightness and watch how your image starts to darken down, then Select····▷Deselect.

Step 5

Repeat steps 2–4, making gradually smaller selections and applying further Brightness adjustments. Three commands should do the trick and providing you keep feathering, you won't see any sharp or obvious edges to your work. Repeat the process in other areas of the image until you have created the emphasis effect. The trick with burning in is to make sure it looks natural and seamless rather than invented.

Step 1 – Dodging

Dodging occurs usually in much smaller areas. Use your Lasso tool and make a careful selection around the area you want to lighten. Next, apply a small feather value to it, about 15 pixels.

Step 2

Next go to Image····❯Adjust····❯Levels and move your midtone slider to the left to lighten this small selection area. If you have difficulty seeing the effect of your adjustment, hide your selection edges.

The Info palette

Like a mini densitometer, you can use the Info dropper, top-left quarter, to measure the effects of your work. It describes full black (K) as 100% and white as 0% and can be used to avoid these extremes that make printing difficult later on.

Chapter 6

ESSENTIAL PRINTING TECHNIQUES

····⟩ Printing single images

····⟩ Making multiple prints

····⟩ Combination printing

····⟩ Cut-outs

····⟩ Printing test strips

····⟩ Printing text

····⟩ Adding captions

Printing test strips

Never expect printer software to make all the corrections for a fault-free print first time round. Making test strips will help you to make fine adjustments before wasting several sheets of paper.

Test strips are second nature to darkroom users, but digital enthusiasts rarely employ the same method, placing all trust in self-correcting printer software. Yet if printing with non-standard media, both brightness and colour balance will need adjusting to fit.

There's no need to copy and paste bits of your image into a new document to make a test strip. Instead print a selection on a custom paper size (see page 92 for more details). This allows you to make the print on a smaller, economic strip, rather than a whole sheet.

Open your image and make sure it's at the correct resolution for printing out. If you change image size or make any other adjustment between test strip and final print, you'll get a different result to your test.

Always print your test strips on the same paper as your final print, as other materials will give different results. If you intend to make more than one test strip, it's a good idea to label each one as it's easy to get confused.

When test strips emerge, give them time to dry as some papers will change colour markedly after a couple of minutes. Colour analysis is best judged in diffused daylight or daylight-corrected artificial light. Incorrect judgements will occur under orange domestic lightbulbs and greener fluorescent tubes.

Avoid working or printing in a brightly coloured room, as reflected (and coloured) light will give you a false impression of your print. If in doubt, stand and judge your print using the natural light from a nearby window.

Step by step

1. Pick the Rectangular Marquee from the toolbox. Check that it doesn't have a preset feather value.

2. Choose an area of your image that has both highlight, shadow and neutral colour midtones, to help you spot problems easily.

3. Define a selection with the Marquee which is smaller than the size of your intended custom paper. Make sure the selection is arranged in the same orientation as the paper, landscape or portrait.

4. Go to File---➔Print.

5. In your printer software dialogue box, click on Print Selected Area and Centre your image on the paper.

6. Pick your Custom paper size. Print.

RingAround software

An excellent way to make both test strips and a ring-around colour chart is with RingAround software. Designed as a Photoshop plug-in, the process works as an automated Action file, leaving you free to do more interesting things.

A user-defined selection is copied and pasted 28 times into a new document, while different brightness and colour-balance adjustments are made to each one. A description of the adjustment lies underneath each slice, for easy identification.

Once complete, the document can be printed out on the chosen paper then examined to see which adjustment matches the paper stock. Buyers of expensive inkjet paper will only need to use one single sheet of to get a complete range of colour-balance and brightness tests.

Download RingAround

This software has been developed by the author for both Mac and Windows platforms and for the following versions of Adobe Photoshop only: v5.0, v5.5 and v6.0. Versions 4.0, 5.0 LE and Photoshop Elements are not supported.

It is available from the following URL: **www.photocollege.co.uk/actions**

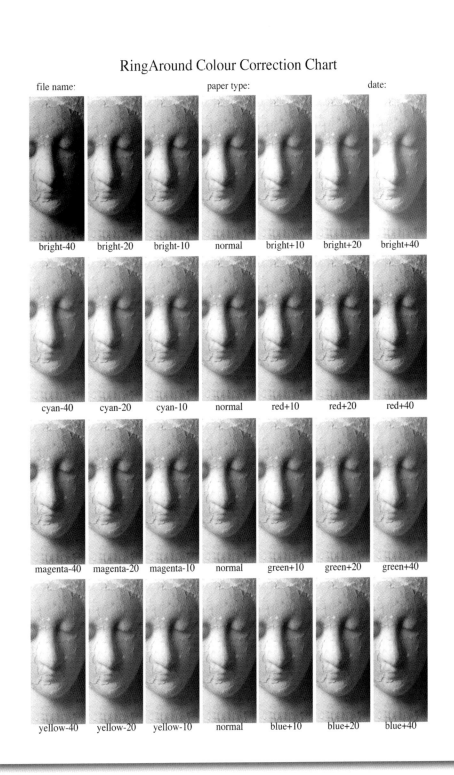

RingAround Colour Correction Chart

file name: paper type: date:

bright-40 bright-20 bright-10 normal bright+10 bright+20 bright+40

cyan-40 cyan-20 cyan-10 normal red+10 red+20 red+40

magenta-40 magenta-20 magenta-10 normal green+10 green+20 green+40

yellow-40 yellow-20 yellow-10 normal blue+10 blue+20 blue+40

Printing single images

One of the simplest yet most confusing issues with digital printing is working out your print size. There are a range of simple tools so you can preview the exact placement and size of your printout.

Unlike a word-processing document, where your final output size is always the same, e.g. A4 or letter, a digital image needs a bit more forethought. Your first task is to set your image at the right resolution for the printing device, such as 200 ppi for an inkjet. Below is a typical Image Size dialogue box for an image taken with a digital camera.

Both pixel size (Resolution) and Document Size are influenced by each other, shown by a tiny linked chain icon in the dialogue box. If you uncheck Resample, then increase your Resolution from 72 to 200, your Document size will get smaller. This is because you have made your pixels smaller. To change pixel size, the process is simple.

Using simple Print Preview

At the bottom left of an image document window, next to the View size indicator is a grey tab. If you click and hold it down, a pop-up window displays a simple print preview of your document.

This takes into account the current image resolution and the current paper size. Greyed out areas at the edges of the Print Preview indicate non-printing areas.

Image Size dialogue box (left):
Pixel Dimensions: 6.19M
Width: 1800 pixels
Height: 1200 pixels
Document Size:
Width: 63.5 cm
Height: 42.33 cm
Resolution: 72 pixels/inch
☑ Constrain Proportions
☐ Resample Image: Bicubic
OK / Cancel / Auto...

Image Size dialogue box (right):
Pixel Dimensions: 6.19M
Width: 1800 pixels
Height: 1200 pixels
Document Size:
Width: 22.86 cm
Height: 15.24 cm
Resolution: 200 pixels/inch
☑ Constrain Proportions
☐ Resample Image: Bicubic
OK / Cancel / Auto...

The camera in question produces images with a Pixel Dimension of 1800 x 1200 and in RGB mode this creates 6.19Mb of data.

When opened in Photoshop, the resolution of digital-camera images are always set to 72 dpi by default. This figure indicates the current size of the pixels, not image quality, print size or anything else.

Now notice how the Document Size (called Print Size in v5.5) of 63.5 x 43.2 cm seems enormous. This is because your pixels are too large at 72 dpi and would print out as visible square blocks of colour.

Step 1

First, make sure you uncheck the Resample Image checkbox, shown above on the bottom left of the dialogue box.

Step 2

In the Resolution box change 72 to 200. Notice how the Document Size has now decreased.

Step 3

Check that your Document Size does not exceed your paper size. If it does, then click on Resample Image and reduce the Document. This will throw pixels away.

Golden rule

The Resample Image checkbox performs two very important, but very different tasks.

Unchecked, it allows you to alter the size of your pixels, but keeps all original image data intact.

If Checked, it will add new pixels (interpolate) to make a bigger print or discard original pixels to make a smaller print, with both affecting data size.

SCENARIO 1

If your Print Preview dialogue looks like the one above, there are three possible causes which you should check in this order:

a. Paper Size is too small
Go to your Printer software dialogue and change the Paper Size back to A4. It's probably on Postcard, or a custom size.

b. Image Resolution is too low
Go to your Image Size dialogue and look at the Resolution. It's probably set on 72 dpi. If it is, follow the steps on the previous page to alter it.

c. Pixel dimensions are too big
If you've doublechecked both a and b, you have got more pixels than you really need. Discard pixels by selecting Resample and reduce the Document Size dimensions (Print Size in v5.5).

Reversing out of a mistake
If your resampling or resizing goes wrong, hold down the ALT key and press the Reset button in the Image Size dialogue box, appearing in place of Cancel.

You will then be returned to your original starting point.

SCENARIO 2

If your Print Preview dialogue looks like this, then there are three potential causes and you should check them in this order:

a. Paper Size is too big
Go to your Printer software dialogue and look at the Paper Size. It's probably on A3, or a custom size. Change it back to A4 or the paper size you intend to use.

b. Image Resolution is too high
Go to your Image Size dialogue and look at the Resolution. It's probably set on a high value like 2400 dpi which often occurs when using a film scanner. If you don't specify an output resolution, the image will hold on to the scanner input resolution value of 2400 dpi. Follow the steps on the previous page to alter it.

c. Pixel dimensions are too small
If you've doublechecked both a and b, you have less pixels than you really want. This occurs when trying to print very low-resolution files, like those downloaded from the Internet, images from sub megapixel digital cameras or low-resolution scans made in error. If you can rescan, do it. If you can't get hold of a better original, try enlarging, but you won't get a good result.

SCENARIO 3

If your Print Preview dialogue looks like the image above, then there are two potential causes and you should check them in this order:

a. Your image orientation is wrong
If your image is presented in a portrait (upright) format when it should be horizontal. Change it using Image·····➤ Rotate Canvas. This occurs when shooting portrait-format images on a digital camera.

b. Your paper orientation is wrong
Go to your printer software dialogue and change from Portrait to Landscape. When you next check the Print Preview pop-up in Photoshop, it should change to a Landscape version, as illustrated below:

Making multiple prints

The terms Image Size and Canvas Size can seem confusing if you are trying to work out how to print more than one image on the same sheet of paper.

Terminology explained

Image Size and Canvas Size are always the same size, unless you decide otherwise. Making a Canvas Size adjustment simply adds blank space around your existing image, so you can add other items such as text, a background border, or another image.

You would never choose to decrease Canvas Size to crop an image because there are better tools to do this job.

Canvas Size and colour

New and empty space created by an increase in Canvas Size will be created with the current background colour. If you never intend this colour to be a feature of your printout, then make sure White is the colour you select.

Canvas Size and Layers

When increasing the size of your canvas. the adjustment occurs without creating an extra layer.

Reasons to increase Canvas Size

If you want to print out a montage or design where you have precise control over the placement and size of more than one image. You can also print off designs that include type.

The following example uses additional canvas space for text and a thumbnail image.

Using the Canvas Size dialogue

Do Image····↘Adjust····↘Canvas Size and look at the current width and height. The Anchor icon at the bottom of the dialogue gives you the chance to specify the position your image will assume when new space is created. By default, the grey square, representing your image, is placed centrally.

With each increase in canvas size, your document data will increase too, because you are introducing new white pixels into your bitmap.

Working with new canvas space:
The example below was originally 17.5cm wide (top). The canvas width was then increased to 35cm, effectively doubling the width of the image (middle). The extra white space was used to place text and an additional image (bottom).

Using Picture Package

A very useful and time-saving tool is the automated Picture Package function in Photoshop. Found under File⟶Automate⟶Picture Package II, it steps and repeats an image to fit a designated print paper.

Uses

If you want to take all the manual effort and human error out of assembling a multi-print page by the copying and pasting technique, then this is the best way to go about it.

Good for maximising the cost of your paper stock and getting better value for money from an Internet printing service.

The dialogue box

You can work on your currently opened image or select an unopened document. All changes occur in a specially created document, so your original is left untouched.

After specifying a resolution, there are several different Layouts to choose from. This example (right) was printed in two different sizes, five up on a single sheet of paper.

If your image doesn't fit the resize format chosen, it will be scaled down within the shape rather than cropped.

Borders and simple edges

There's no reason to print out all of your images with clean-cut edges, as its easy to mimic the look of an enlarger mask edge.

Making a negative carrier edge

Rough edges made in the darkroom using a filed-out negative carrier can give your prints a personalised 'signature' and, because they are printed full frame, demonstrate your skill in previsualising the shot.

Step 1

The above textural image lacked any distinct edges. Unlock the Background layer by double clicking on its Layer palette icon and rename it Layer 3. Create two new layers, call them Layer 1 and 2 and place them below Layer 0. Make sure Layer 1 is on the bottom, 2 in the middle and 3 at the top.

Step 2

Set your Background colour to white and increase the Canvas Size to 110% in each dimension.

Step 3

Click on Layer 1 and Edit⟶ Fill⟶ Background colour with White. Your image should now be surrounded by a solid white border.

Step 4

Next, click on Layer 3 and, to select the image edges, do a Command/Cntrl click into the tiny layer icon in the layers palette. A square selection icon will appear over the normal hand cursor as you do this.

Step 5

Once selected, click on the empty Layer 2. Next do Select⟶ Modify ⟶ Border. Set 16 pixels as the width. Notice a double edged selection now hovering around your image.

Step 6

Using the dropper tool, pick the darkest tone from your image and set it as the Foreground colour. Do Edit⟶Fill and fill the selection. Notice the edge appear for the first time.

Step 7

It looks a bit uniform and false at the moment, so to roughen it up, select the eraser from the Tools palette.

Step 8

Your Layers palette should look like the illustration above. Set the Eraser to Airbrush mode with 50% pressure. Next, start to remove bits of the border on Layer 2.

Step 9

Click on the image Layer 3 and also remove some of the edges to create a softened outer line. Don't overdo it, but aim for a result that just takes the sharpness off.

Other materials to use

Keep an eye open for prints, packaging and torn scraps of paper that could be scanned and used to make a library of edge shapes.

Finished result (above)

It will take some time to get the hang of knowing which bits to remove. If you don't have a steady hand, keep one finger on the Shift key when erasing and it will be locked into working in a straight line only.

Rough edge (right)

This image was created using the same technique for emulsion edges (pages 84–85), but using a ripped sheet of black paper as the scanned source material.

Extensis Photoframe

For details about this excellent Photoshop plug-in edge creator, go to page 148.

Liquid emulsion edges

The darkroom technique of liquid emulsion is much favoured by photographers keen to create a halfway house between a painting and a photograph. Yet the traditional process is not exactly straightforward, needing a degree of patience when things don't go as planned.

Step 1

Open your photographic image and make any corrections or manipulations you need to. Open the edge image and convert it into RGB mode. Keep both images open on your desktop at the same time. Next make the black emulsion image the active image window, then select the Magic Wand tool. The Magic Wand works like a magnet and attracts pixels of a similar colour into a selection area. Its pulling power, or tolerance, can be set low to attract only similar colours or high to attract a broader range. ---⟩

Step 2

Click with the wand anywhere inside the black shape. If white areas areas are included in your selection, do Select---⟩Deselect, then reduce the Wand's tolerance to 10 and try again.

Now you'll notice that any black areas lying outside the central shape aren't included in your selection, so to remedy this do Select---⟩Similar. Now every black pixel in your emulsion image will be selected ready for the next step.

Next, without closing your emulsion image, make your photographic image the active window. Then do Select---⟩ All, then Edit---⟩Copy. This sends a copy of your image to your computer's clipboard. Close down the landscape image, as you don't need it any longer. The next step involves using an unusual command: Paste Into.

This places your copy only inside the selection area and creates a kind of mask or stencil, shown in the Layers Palette (below). ---⟩

Step 3

Next, make the emulsion image the active image window, then do Edit---⟩Paste Into. If your image suddenly loses its colour (as below), you haven't changed your edge image into RGB.

Step 4

Once the image has been pasted in, pick the Move tool and click drag it on your image until it's in the right place. Your former selection now works like a stencil, allowing your image to appear inside the brushstroke-edged shape.

Step 5

If the image you've pasted in is too big or small, resize it by Edit⸺⸽ Transform⸺⸽ Scale. If you can't see the Scale handles (at each edge and the centre of each side), zoom out using Space Bar+Alt until you can see them. Don't distort your image at this stage; either hold down the Shift key and drag a corner handle or, even better, hold down Alt+Shift together and watch your image resize from the centre. Pulling inwards reduces and pulling outwards enlarges your image. ⸺⸽

Step 6

A good variation is to use Edit⸺⸽ Transform⸺⸽Scale to pull the image inside the brushstroke edges, so it looks as if it is printed full frame. To change the colour of your emulsion from black, click on the Background layer, then select a new Foreground colour. Rather than pick one at random from the Colour Picker dialogue box, pick the Dropper tool and click in a dark area of your image to select a new Foreground colour. Use your Paint Bucket to drop this new colour in (shown below).

Making your own edges

If you want to make your own emulsion edges, get a sheet of white A4 copier paper and a pot of black Quink fountain-pen ink or a tube of black acrylic paint. Get a bristly half-inch paintbrush from your local DIY store and drag your brush across the page for a scratchy-edged effect. Place it on a flatbed scanner and scan at 300 dpi in Bitmap or Lineart mode. As there's a lot of fine brushmarks, you will need to scan at 600dpi to capture them all. Don't scan the whole A4 sheet; instead, drag your marquee as tightly around your black shape as you can, as it will make your file leaner.

Next, open the file in Photoshop and then convert it to the right mode. You can't go from Bitmap to RGB colour mode in one step; first you have to convert it to Grayscale via Image⸺⸽Mode⸺⸽Grayscale. When prompted by the Grayscale Size Ratio dialogue box, enter 1. This keeps your Bitmap at 100% size in the new mode. If you enter 2 or 4, your image will be half or quarter size respectively

Now convert your Grayscale to RGB mode. If your original black-ink painting was far from perfect, or if you want to fill in any streaky areas, do this next. Only the black areas will show your overlaid image, and any white lines will appear white in your final printout. To remove them, use the Airbrush tool, set with a hard-edged brush at size 100 and pressure 100%. Save your results.

Download emulsion edges

If you don't want to make your own edges, there are seven emulsion edges for free download at **www.photocollege.co.uk/edges**

Scanning paper textures

If you want to make a print that has the feel of an artist's paper, but with all the high-quality advantages of a purpose-made inkjet paper, you can cheat a little.

Step 1

Scan a piece of textured paper, or even fabric, on a flatbed scanner. Capture in RGB mode and to make a large original, set your scanner input resolution to 300 dpi. If your paper is monochrome, like writing paper, change the mode to Grayscale and save and store as a TIFF file.

A good idea is to build up a library of paper textures, colours and finishes and make high-resolution scans and store them on a CDR for future use.

When you are ready to use one, create a desirable base colour using your Colour Balance command and use Levels to alter contrast.

Avoid making colours and contrast too intense, as the background paper only needs to show the slightest tone and texture and not pull attention away from your main image. ⤐

Step 2

This mottled example was a rather mouldy endpaper found in an old book, but after scanning and colourising it added a interesting textural effect.

After opening the textured paper image, simply copy and paste your photographic image on top, to create an extra layer, shown below as Layer 1.

This example had a mask applied, shown as the black and white icon with the 'hole' in the middle. ⤐

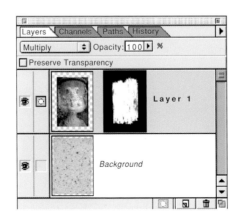

Step 3

After floating your new layer into position, simply change the Layer blending mode to Multiply. This has the effect of dropping all the image highlights which are lighter than the underlying textured paper layer. Both paper texture and image detail are merged perfectly to make a convincing result, shown on the opposite page.

Modifying imperfect papers

Don't be put off scanning or using materials which are not 100% perfect for your uses in their current state. After scanning you can easily remove imperfections or even large areas of original detail by using the Rubber Stamp tool. The shape can also be modified to fit your image by simply cropping.

Printing out

There will be little tweaking needed if you print onto a good-quality non-gloss inkjet paper like Somerset Velvet Enhanced or Lyson Soft Fine Art.

Cut-outs

Cut-outs are images that have been stripped away from their background and printed as irregular shapes.

The hardest task of all is to make an accurate selection of an object in order to remove an unwanted background. There are many tools that claim to offer quick-fix solutions to this problem, but the only one to consider is the Pen tool.

The Pen tool creates a vector outline called a Path and uses the same kind of line and curve describing tools as a vector drawing package like Illustrator. Bezier curves can be easily pulled and bent into shape, so the Path makes an exact fit around the object and they can be converted into selections.

Step 1

Work on the highest-resolution version of the image in your possession, as imperfectly cut edges will be less visible after resampling. Open your image and make sure you are viewing it at 200%. Pick the Pen tool from your palette and start clicking points inside your desired shape.

Step 2

As you move around curved areas, click and drag your cursor to create Bezier handles. You can push and pull these to make the line fit exactly around the shape.

Step 3

Complete a fully enclosed Path, joining the last point to the first one. In your Paths palette double click on the Path icon and save it with a recognisable name. Unlock your background layer, or rename it Layer 1.

Step 4

Now select the Path by clicking on the Path icon in the Paths palette (as shown above). From the pop-out menu, select Make Selection. The dotted lines will now appear in your image. Deselect the Path by clicking under it in the Paths palette.

Step 5

Do Select····▸Invert to select the background then do Edit····▸Cut to remove it.

Step 6

Once the background is removed, you have a clean-edged shape ready to print or manipulate. The example below had a drop shadow applied before printing and, on the opposite page, was combined with a sheet of scanned paper.

Printing text

If you want to print ultra-crisp text, you'll need to prepare your image file at a higher resolution than normal and print out with purpose-made inkjet paper.

Vector type

Creating type in Photoshop makes a unique vector layer, i.e. one not containing pixels. When flattened, the vector type layer assumes the resolution of the host image document. Leaving type layers as vectors means they print out at the highest printer resolution setting.

Visible appearance of type

It's much easier to spot jaggy text on a low-resolution printout, because type has a very tightly defined and recognisable shape compared to photographic images.

Image resolution

If you intend to have a text element printed as part of your image file, then you must start out with your image at 300 ppi rather than the normal 200 ppi for inkjet output.

Rendering type layers

You can convert vector type into pixel type at any time by a process called rendering, but if you resample, the type will scale to fit without losing quality.

Pixel-filled type

It's possible to fill chunky and solid letterforms with pixels, rather than type colours and gradients, by using Photoshop Type mask tool. If you've got hard-edged and small text, start off at 300 ppi.

Paper choice

Maximum type sharpness will come from using a purpose-made uncoated inkjet paper with a matt finish.

Sharpness with other media

Other uncoated papers like watercolour, writing paper and litho paper will make inkjet dots bleed into each other, so despite a high image resolution, you'll never get pin-sharp results.

Anti-aliasing

Photoshop type can be created using an anti-aliasing option which will smooth out the evidence of jaggy staircasing, most visible on curved lines.

Third-party output and fonts

If you intend to have your images printed out by a professional lab or service, you must flatten your image before sending it off.

If you supply an image with unflattened vector type layers, the bureau's version of Photoshop will look for the original fonts that you have used in your artwork. If they can't be found and it's most likely the won't be, Photoshop will substitute another font in its place.

Your results will, of course be very different to your expectation. Get into the habit of supplying TIFFs as they don't support layers.

Above top is an image printed onto purpose-made paper at 300 ppi. Above bottom is the same file printed on recycled paper and losing sharpness as a result.

Adding captions

There's a hidden part of Photoshop that is rarely used but is most useful for adding shooting notes, captions and copyright information.

Deep in the innards of Adobe Photoshop is the File⇢File Info dialogue box. Here you can add a caption, plus descriptive keywords which can be used by an image database to search for your work.

This information always remains hidden, and never appears on the monitor display or in the printed result, unless you decide otherwise. Info can simply be highlighted and deleted once used or when the need for updating occurs.

File compatibility

On Mac OS platform, all File Info text is saved with all file formats but on Windows only PSD, TIFF, JPEG, EPS and PDF files are supported.

Usefulness

There's absolutely no reason to use a page-layout programme like QuarkXpress or Pagemaker just for adding a few captions or lines to your printout. Instead, you can choose the Print Caption option in your printer software dialogue box.

Image instructions

You can use the File Info function to list your specific instructions to a repro house or print bureau. Captions are also an essential part of the trade of any freelance photojournalist or busy studio photographer who needs to label the never-ending procession of products!

Adding file information

Open File Info and select the Caption option from the drop-down menu. Type in, or copy and paste your caption in from a word-processing document. You can add about 300 words here, which is more than enough to capture all your thoughts and instructions. Don't use hard returns when entering your text.

Printing out

In your Page or Print Set-up dialogue box select the Print Caption option, shown above in the orange box . Type will be printed using Helvetica font at 9 point size only and your text will be aligned centrally (bottom right).

Making space

Captions will only be printed out if there is enough space on your print paper to accomodate them. Check your print size dialogue box beforehand and remember to leave a gap between your image and the edge of the paper.

Test strips

Adding caption information is an ideal way to annotate test strips, contact prints or any other reference printouts you are likely to make which would benefit from labelling. For scientific or factual images, captions can give an instant indication of essentials like date, subject and author.

Custom print shapes and sizes

You don't need to print everything on rectangular sheets of paper – you can create custom sizes to fit panoramic or unusual-shaped images.

You can buy panoramic format paper, but if you want to print on your own cut-down paper, you need to make a custom paper size. In your Printer software dialogue box click on the Customize button and this will take you into the next dialogue. Type in the dimensions of your paper. Be exact as the printer will use these figures to place your image in the centre of the paper. ⋯⋯▷

Double click in the scrolling box and give your custom paper a name that you will recognise. It will remain as Untitled if you don't. Press OK. ⋯⋯▷

Now you are taken back to the print dialogue box. Click in the Paper Size drop-down menu, where you will find your Custom paper size. This one is called Panoramic. This now stays in your Print Set-Up dialogue indefinitely.

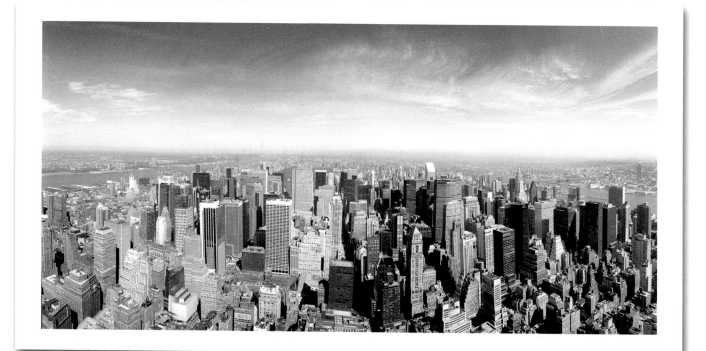

CD covers and contact sheets

The best way to archive your images is on a CD, but unless you have a printed contact sheet there is no way of finding the image you're looking for.

From Photoshop 5.5 and upwards, a number of useful Automate commands let you create a contact sheet from a folder or directory of images. A contact-sheet cover makes your work more visible and easier to retrieve. You can get about 36 recognisable thumbnail images on the rear cover of your CDR case, together with filenames for easy reference.

Rear contact sheet
Step 1
Insert your CDR disk and count the number of different image files which are on the disk. Open Photoshop and from the File Menu, select Automate⋯⟶Contact Sheet II. ⋯⟶

Step 2
Under Source Folder, click on Choose and select the disk you want to catalogue. Click on Include All Subdirectories if you've got any images stored in subfolders. ⋯⟶

Step 3
Next customise the document size to fit the dimensions of your CDR case. For most cases, 13.7cm x 11.7cm will suffice. If you intend to print out with an inkjet printer, make the Resolution 300 dpi, as you'll be printing text⋯⟶

Step 4
In the Thumbnails dialogue, configure the Columns and Rows up to a maximum of 6x6. If you have any more images, then you will need to print more than one contact sheet. Click on Use Filename as Caption, so you have an exact reference for each image. ⋯⟶

Step 5
Press OK and watch Photoshop assemble your custom-sized contact for you. Once finished, Flatten the image. ⋯⟶

Step 6
Finally, print out selecting Corner Crop Marks in the Page Set Up dialogue. This makes it easier to cut the contact out when printed on a larger sheet of paper.

paper textures 1

Front cover sheet
You can easily make a front cover by specifying the right-size document.

Step 1
Do File⋯⟶New and make your document 24cm wide x 12cm high. With a central fold, this corresponds to the size of a CDR box front cover. ⋯⟶

Step 2
Next turn on your guides View⋯⟶Show Guides, and pull down a horizontal guide to the centre to mark the fold of your cover. ⋯⟶

Step 3
Create your design on the right side of this centre line. Use the left side of the centre for technical info like file sizes etc. ⋯⟶

Step 4
Print out with crop guides, cut out, then fold to fit your case (above, middle).

Chapter 7

MONOCHROME TECHNIQUES

Monochrome printing

Just like the craft of printing photographs in the darkroom, grayscale printing can be a demanding task. If you are really keen, specialist materials are available for cast-free prints.

Grayscale images do not use the same RBG ingredients as colour images. Instead they use a simple black to white range from 0 to 255. With a third of the data size, grayscales can still produce very subtle tonal changes in a print and there are lots of different methods to try.

Black or Colour inks?

When setting up your printer software, never choose the black ink only option, as this will fire ink from only one ink reservoir, black. The results will look very dotty and crude because the other five inks have been left out and you've effectively divided your printer's output resolution by six. Always print using the Colour option, even though your image is monochrome.

Grayscale or RGB mode?

You may get some surprisingly different results if you convert your grayscale to RGB before printing because the printer software will have a different source to convert.

Making neutral prints

If you've ever tried printing black and white negatives onto colour photographic paper in the darkroom, you'll know that a neutral print can be a very difficult thing to achieve. The best way to achieve a neutral print is to make careful tests with each different paper

you use, then correct any imbalance in the Save Settings option in your printer dialogue box. All papers will react differently to inks, so you shouldn't expect miracles first time round.

The professional approach

If you are very keen on monochrome digital printing, then the best way to approach it is to buy a separate printer for monochrome output. Combined with dedicated mono ink cartridges such as the Cone Tech Piezography BW6, you can have a purpose-built system for very subtle results. Just like investing in a purpose-made black and white enlarger, buying a second inkjet printer is not as extravagant as it sounds. Many keen black and white photographers opt for older Epson printers such the Stylus Photo 1160 or 1200 models, purchased easily as refurbished kit or as a second-hand deal.

Lyson Inks

Lyson's Quad and Hex black cartridges give a photographer the chance to print tonally rich cast-free images. Quad and Hex Blacks are designed to replace the four and six colour cartridges in Epson printers and contain black in six or four strengths respectively. With six shades of black through to light grey, these enable you to print a monochrome image without resorting to a CMYK, LC, LM mixture.

The cartridge works because the different black and grey inks are loaded into their tonal equivalent colour pods and are 'called' up by the printer software when making a print. As these third-party materials are not catered for in Epson printer software, Lyson can supply you with detailed paper and video instructions for greater colour accuracy.

Flushing the colour ink out

Before you swap ink cartridges, it's essential that you use a proper printer head-cleaning cartridge to remove all traces of coloured ink from the head. Follow this with a couple of full-sized prints just to make sure.

Good products like the Cone Tech range come with special software and profiles to help you achieve better results.

Correcting colour casts

If you do choose to use your colour inks to make monochrome prints, the wedges to the left illustrate the kind of problems you will encounter.

Identifying the colour

If you are not familiar with colour printing, identifying the cause can be trickier than it seems. The best bet is to buy a Kodak Grayscale wedge, often used by professional photographers to monitor contrast and tonal separation when photographing tone critical artwork. Compare your step wedge to the neutral Kodak wedge, looking to the midtones for the telltale signs.

Guess the imbalance

Take a look at the five wedges to the left and guess the colour causing the cast for each one (answers at the bottom of the page).

Casts in different tonal sectors

One of the big difficulties when printing with coloured ink is the appearance of different colour casts in different areas of the wedge. To correct one imbalance will adversely affect the other, so a fully neutral end result may never be possible. To try and correct the casts, use your Colour Balance controls and make full use of the Highlight, Midtone and Shadow options in the dialogue box. Remember, an over-correction may cause a new cast, so be cautious.

Answers

From the far left: slightly red; magenta in the midtones; magenta in the highlights; blue in the midtones; yellow in the midtones.

Mimicking infra-red film

Using monochrome infra-red film can be a challenging task, made more difficult if you don't have your own darkroom. You can mimic the look of the effect with a few crafty steps in Photoshop.

Step 1

The original image below has all the prerequisites for an infra-red effect print: plenty of green foliage. Yet, when scanned, the greens from the original transparency lacked vibrancy. Greens can often reproduce with lower than expected saturation, particularly when shooting under cloud cover.

You can make infra-red prints without fiddling with colour values, but for a more vivid result, it's much better to bump up the greens before starting.

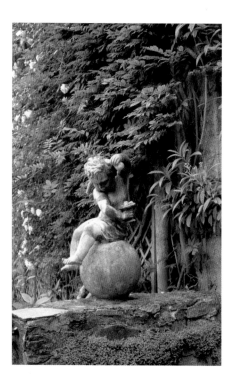

Step 2

There's no need to make a long and complex selection of all the green elements in your image. Instead, to make your greens appear brighter, do the following command:
Image····≻Adjust····≻Hue/Saturation. From

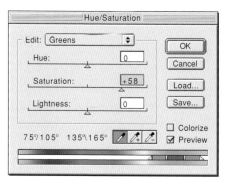

the Edit drop-down menu at the top of the dialogue box, pick the Green option. This has the effect of limiting your adjustments to one colour only.

Move the dialogue box to one side of your image, so you can see clearly the result of any change you make. Click on the Saturation slider and move the triangle to the right-hand side of the range. You'll notice that your greens have now become a lot brighter.

Try and push the Saturation of your greens until they look slightly over the top. In this example an adjustment of +50 was made.

Step 3

After increasing the greens, your result should look like the image below (the intensity of the colours here is reduced somewhat by the CMYK colours used to print this book).

Before the next stage, make sure you have burnt in and darkened down any bright areas of your image.

Any near-highlights may be bleached out, so use your Info dropper to double check if you are uncertain.

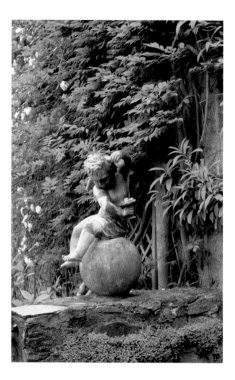

Step 4

Now to convert the colour image into the ethereal infra-red effect, do the following command: Image⋯⋯Adjust⋯⋯Channel Mixer. The Channel Mixer lets you remix the quantities of each colour in their separate colour channels, a bit like shooting photographs using colour separation filters.

To make your image take on a monochrome outcome, click on the Monochrome check box, found at the bottom left, as shown below.

Next, increase the quantity of Green to the maximum +200% and type −50% in both Red and Blue channels, as shown below:

Step 5

Finally, to add a touch of warm tone, do a Hue/Saturation Colorize command as shown below:

Selective toning techniques

As when using a paintbrush and inks, you can selectively tone with two principle methods.

Cut-through toning

1. You can work with any kind of image mode but make sure it's converted to RGB first.

Make your brightness corrections beforehand and then duplicate the Background layer by click dragging the Background layer icon over the New layer icon, found in the bottom row of the Layers palette. This will give an identical copy of your image which will be used for toning, leaving the untoned image lying directly underneath, but will double your document's data size.

2. Click on the Background copy layer and tone this using the Hue/Saturation dialogue. Click on Colorize and make the layer a weak sepia colour. Next, from the toolbox select the Eraser and set it on Airbrush mode, as shown below. ⌁⋯⋙

3. Change the Pressure to 100%, so it makes a clean cut through your image.

Work on the Background copy layer and cut holes into it to reveal the untoned layer lying underneath. As it's lying in exactly the same place, you'll get perfect registration between the two.

Experiment by erasing at the edges of your image until you create an effect that looks like a faded vintage print. If you cut too much out, backtrack using the History palette.

Painting in colour

1. Next, work again on the Background copy layer, select the Airbrush from the Tools palette and make sure its blending mode is changed from default Normal to Color. Like layers, all the painting tools can be used with different blending modes.┄┄┄┈>

2. Select a large soft-edged brush and click on the colour picker to select a colour. Don't choose saturated colours, as muted ones will look more convincing. Finally, set the Airbrush pressure to 10%.

Paint on the Background copy layer and notice how the Airbrush blending mode preserves all underlying image detail, just like painting with inks on a black and white photographic print.

Avoid dwelling in any one place with the Airbrush, as colour will spread and look unconvincing. Each time you paint in the same place, your previous colour will be lost; there's no overlaying with this mode.

3. Another tool you can use to lessen or highlight delicate colours is the Sponge. Set to Desaturate and on maximum pressure, this will drain colour away like a magic eraser. Yet it will leave image detail unaffected. If you've gone too far with the Airbrush, you can lessen the colour effects with this tool.

If your problem is the opposite and there are colours to be intensified, use the Sponge tool set to Saturate. Experiment with the pressure settings until you are confident using them.

Duotones

Photoshop has many hidden resources and the duotone preset recipes are perhaps the best-kept secret of all. With well-established colour effects accompanied by manipulated curves, presets are the best way to learn how duotones actually work.

Without doubt the most sophisticated way to tone a digital image is to work in the Duotone mode. Duotones are traditionally used in the lithographic printing industry to reproduce high-quality monochrome images, such as those found in high-quality photography books.

In order to reproduce the feel of an original photographic print, perhaps printed on a chlorobromide paper or chemically toned, book designers use additional coloured litho inks.

In basic lithographic reproduction, such as in a black-ink-only newspaper, grayscale images are printed with one colour: standard black ink. Despite 256 levels of grey present in the digital image file, the litho process cuts this down to about 50 and with it all the subtlety of tonal gradation is lost.

The effects of this process on photographic images are disastrous. Economically, each additional ink colour needs a separate printing plate, adding to the overall cost; high quality is achievable but only at a high cost. Yet with the introduction of each new additional ink colour (and plate) a further 50 tonal steps are added.

Surprisingly, duotone mode (and tritone and quadtone) digital images can be printed out by most desktop inkjet printers, so the process need

not only be restricted to litho output. The best aspect of toning in this way is that you can work with a personal swatch of colours, manipulating each in up to ten different tonal sectors. In many expensive art photography monologues, additional warm brown and light tan inks are often used to keep the 'feel' of a photographer's work and part of the book's higher than average cost can be due to duotone (two ink colours) tritone (three ink colours) or quadtone (four ink colours) printing and the complex film separations that need to be made.

Colour selection is made by simply clicking into the colour boxes (to the right of each curve above) and using the Picker or any of Photoshop's Custom colour palettes like Pantone.

If the technical appearance of a duotone curve looks threatening, then it's much simpler than it appears. Standard grayscale 0–255 range is converted to a 0–100% scale in the duotone curve.

The graph is divided into ten sectors, with each square representing a 10% increase in tone; 0% is white and 100% is black. The graph is a straight diagonal line by default, meaning each original grayscale value is substituted with the same percentage of new colour.

To manipulate colour there are two methods you can use. Either click points down on the diagonal line, then push or pull them. Pushing the curve into the pink zone (above) will make the colour more visible, and pulling into the white zone will conceal it.

The second method is to type values directly into the text boxes, which give a read-out of the new colour values, then watch the curve change shape and your image change colour.

Duotone Presets

Found in Duotone Presets inside the Photoshop Goodies folder, these 'recipes' can be applied to your image by pressing LOAD in the duotone dialogue box. ⤳

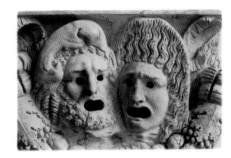

Pantone duotones
Pantone Mauve 4655 bl 1

Grey/Black duotones
Pantone Warm Gray 11 bl 1

Process duotones
Cyan bl 2

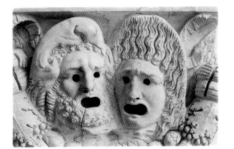

Pantone tritones
Bl 313 aqua 127 gold

Grey/Black tritones
Bl soft CG9 CG2

Process tritones
BCY green 1

Split-toning with tritones

If you want to tone with two or more colours, you can drop each one into a precise tonal sector of your image and, best of all, keep meddling until it looks right. Unlike chemical toners used in traditional photographic printing, duotones allow both time to reflect and a useful reverse gear.

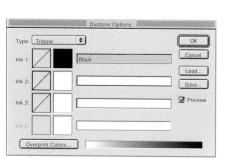
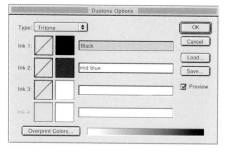
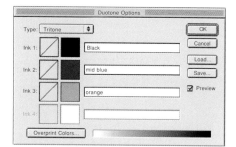

Step 1

You can begin with any image mode, but you must convert it to Grayscale before starting off. Next do Image····▷Image Mode····▷Duotone. From the drop-down box, choose the Tritone option, as this will allow you to specify three different working colours. In the duotone dialogue box, black is set as the default first ink colour and you'll see empty boxes next to Inks 2 and 3. ····▷

Step 2

Click into the empty white square next to Ink 2 to reveal the Colour Picker. Choose a mid-blue and type in the colour description as shown. As soon as you have picked a colour, Photoshop updates your image behind the dialogue box to reveal its effect. Don't worry if it looks too saturated at this stage, as we haven't adjusted the curves yet. ····▷

Step 3

Next define your third working colour, but this time choose a bright orange. The effect of this colour will seem to cancel out the previous blue, but you can bring it back later on. Your image should now look quite heavy, as above. ····▷

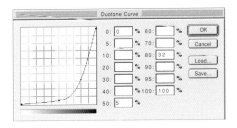

Step 4

Now return to Image·····▸Image Mode·····▸Duotone to bring back the dialogue box and click on the diagonal line graph next to the Black ink box. This brings up the duotone curves dialogue box. Type 5 in the 30% text box, 30 in the 80% box and drop the 100% box to 98. ·····▸

Step 5

Next you need to adjust the blue. Type 40 in the 50% box and in the 100% box type 77. You can pull the curve shape into position if you want, but it's much easier to enter values in the text boxes. If you go too far, just backspace or type in a new value. ·····▸

Step 6

Finally adjust the last colour, orange, to make it more visible. Create an unusual curve shape by entering these values: 0 in 100%, 34 in 50%, 26 in 30% and 18 in 20%. This has the effect of taking virtually all orange out of the midtone to shadow areas, leaving blue to dominate.

Lith-printing process

Conventional lith printing is fraught with unpredictable chemicals and extraordinary exposure times, all leading to an uncertain end result. You can mimic lith printing using Curves.

Lith printing is unusual. A combination of both high-contrast and low-contrast areas in the same print, plus a base colour ranging from pink to orange. Image contrast is controlled by enlarger exposure. Developing prints can pose problems too, and after an unnerving delay of five minutes or so, the image appears suddenly with increasing shadow areas. Infectious development spreads like wildfire and the difficulty is in knowing when to pull it out of the dish.

In Photoshop you can reproduce the process using Curves, but with full control over shadow build-up. Any original will work, black and white or colour. For colour originals make an Adjust····▷Desaturate command to drain away the colour. For Grayscale images, change to RGB mode first.

The process, like the conventional darkroom version, works best with low-contrast originals such as the landscape above.

Step 1

To introduce a base colour for the project, use Image····▷Adjust····▷Hue/Saturation. Here you can create a pink, orange or brown effect by clicking on the Colorize button, shown above on the bottom right of the dialogue box. Move the Hue slider along until you get the desired colour. Don't use the Lightness slider as it only makes crude holes in your highlights.

Use the Saturation slider to reduce the intensity of the colour. It's not necessary at this stage to apply a saturated effect. ····▷

Step 2

Reduce the contrast of your image with Image····▷Adjust····▷Brightness/Contrast. Use the Contrast slider to make your image look very flat. This example had a minus 50 adjustment, but each image will require a different amount. This low-contrast reduction will serve to create the familiar flat highlights in the final image.

Adjustment layers

Unlike image containing layers, adjustment layers hold only settings information and do not increase the file size of your document. You can return to your settings at any stage and make modifications. ····▷

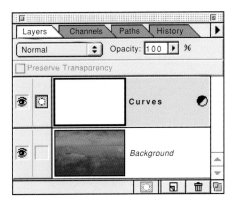

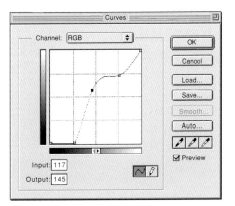

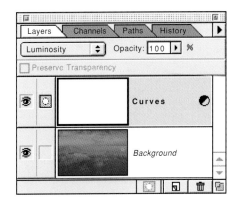

Step 3

Next make a Curves Adjustment layer by clicking the tiny black triangle on the top right corner of your Layers Palette. Select a Curves adjustment layer. ┈┈┈⟩

Step 4

Next click three points on to the curve, at each of the quarter markers. Pull the curve into shape as shown above. You will see your image change with each pull. ┈┈┈⟩

Step 5

Finally, merge the Curves adjustment layer with the background layer using the Luminosity layer blend. You can also vary the Opacity.

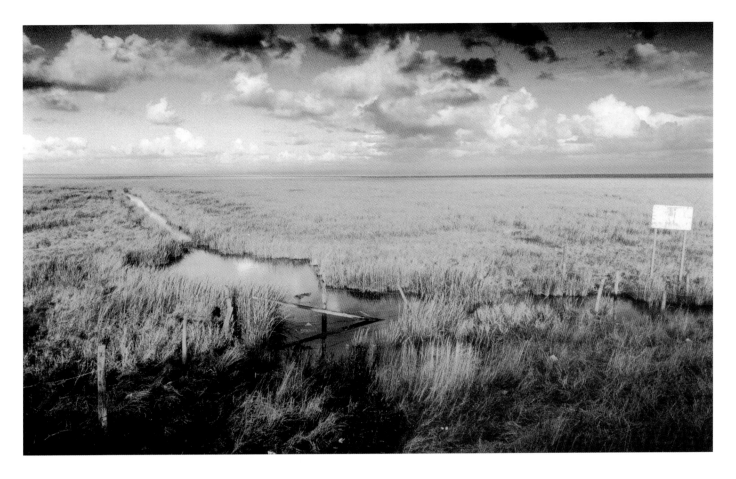

Low-contrast printing

If you've never seen the delicate tonal range of a carbon or platinum print, low-contrast printing will seem an old-fashioned process.

Low contrast

1. Start with a high-contrast original, which can be identified by high peaks at both ends of the Histogram graph found in the Levels dialogue. Adjust your white and black points if need be before starting. This image (top) is a 1920s lido, and will suit a modernist-period print style, such as a carbon print.

First convert your grayscale to RGB mode, or if it's RGB to start with, do Image⸱⸱⸱▷ Adjust⸱⸱⸱▷ Desaturate to drain the colour away (bottom).

2. Apply a tone to your image using the Colour Balance command found in Image⸱⸱⸱▷ Adjust⸱⸱⸱▷ Colour Balance. Click on the Midtone ratio button and drop a warm brown colour onto your image. Use a mixture of Red and Yellow, as above to make this effect. Avoid going too far or you will overcook the effect.

Next, without closing the Colour Balance dialogue, click on the Highlight ratio button and repeat the colour change, increasing the quantities of red and yellow (bottom) This has the effect of putting some colour in the highlights.

3. Finally, open your Levels dialogue and in the Output Levels gradient patch, found at the very bottom of the dialogue, move the shadow (black triangle) towards the centre. This resets the black point and changes the darkest part of the image into a grey.

When printing out, avoid using any contrast correcting printer functions that may alter your deliberate command. Textural off-white papers, with the feel of a vintage print, work best.

Salt-print process

Photography lost most of its hand-rendered qualities once glass-plate negatives and smooth albumen papers appeared in the nineteenth century.

Before the gelatin silver print became the automatic choice for black and white photographers, nineteenth-century practitioners developed a number of alternative printing processes. They were unpredictable, prone to fading and without the sophisticated tonal range we have now come to expect.

However, at the turn of the century, when photographers Robert Demachy and Alfred Slieglitz had a collective purpose to correct the unpicturesque, highly manipulated printing routines were developed to distance these new artist photographers from the mechanical appearance of the photographic image.

Digital has now brought about a second return to craft printing processes.

Photoshop principles

Most traditional sunprinting techniques follow exactly the same stages: preparation of the negative, sensitising the paper, then printing out. These three stages can be easily recreated in Photoshop.

Source images can be created as grayscales, pigment and print emulsions can be matched by using carefully chosen duo- or tritone ink colours with textures and edge effects introduced as separate layers. When using the duotone mode, an extra

colour is combined with black, e.g. brown for reproducing the effect of a sepia-toned print. With tritone or quadtone options you can add a second and third colour to create a richer tonal range and still retain the file size of a grayscale image. This is a bit like having an infinite selection of chemical toners to dip your black and white prints in.

Finally, the precise positioning of these colours in your tonal areas can be achieved using the duotone Curves controls. To mimic the effects of the historic printing paper, print onto a good-quality handmade cotton paper or even track down some old sheets of faded watercolour paper.

Making a salt print

Original salt prints are brownish in colour with a fibrous texture due to the use of a paper negative. You can reproduce this technique by starting with a full-toned grayscale image scanned from a negative or print. The next stage is to mimic the paper texture by introducing a new layer to your image. Using your flatbed scanner, scan in an A4 piece of blank textured paper as a grayscale. Increase the contrast considerably until the surface texture shows.

Make it into a tritone with Pantone Process Black, Pantone 407 CVC and

Pantone 4495 CVC as your three colours. Experiment with the curves for each colour until you achieve a result. Keep the second colour at only 20% in the 100 box.

Next, cut out the background surrounding your scanned image and use the remaining object, in this example the grass, to make a selection outline. Then change layers and use this selection to cut a hole through the paper texture layer. Next discard the grass layer equivalent, cut an irregular edge to your image and darken the edges to mimic fading.

When printed, the base colour of your print paper will show through the cut, as shown to the right.

Chapter 8
Colour Techniques

Burning-in with colour

Rather than carry a camera bag full of filters to enhance your colour photographs, you can easily apply them retrospectively in Photoshop.

Step 1

This image was taken on colour negative film on a late winter afternoon. Although the detail in the sky fits the mood of the picture, an extra bit of colour might just improve it. Before starting off, try and visualise your end result rather than setting off without a clear plan. The idea behind this technique is to introduce an extra bit of red into the sky, without looking as if we had falsified the print.

There's little point trying to paint colour directly onto an image using any of Photoshop's painting tools, as you will destroy underlying detail and end up with noticeable brushmarks. A much better bet is to make Colour Balance adjustments within selection areas.

Just in case you make a mistake, make a duplicate background layer of your image and carry out your colouring work on this layer, rather than the more precious original.

Step 2

Use the lasso tool and draw a very rough selection around the area you want to alter, as above. Don't be too precise at this stage as the selection edge won't be visible. For a convincing effect, try and imagine the most likely place for your colour change to occur. In this example, the heavy overhead clouds to the top left were ideal.

Step 3

Next, to prevent your selection edges looking sharp, do Select····❯Feather and make it about 50 pixel radius. This will give you the kind of invisible edge achieved when burning in in a conventional darkroom situation.

Step 4

Once you've made a selection do Image····❯Adjust····❯Colour Balance and increase the quantity of red as shown in the dialogue box below. Try and burn colour into the midtone areas to start with, but if the effect is limited, try clicking on the Highlight option and repeat the process.

Don't try to introduce too much colour in one go, but make smaller and smaller selections, as shown above, followed by colour-balance adjustments.

The end result, shown opposite, has a subtle colour change, rather than an obvious filtered effect.

Burning in with gradients

If you've been shooting landscapes on transparency film, you can rescue those pale, washed out skies by burning them in with the gradient tool.

Step 1

Exposure is a problem with transparency film, especially when you are trying to capture land-bound shadows with sky-bound highlights on the same film frame. This example was shot slightly into the light and the resulting transparency had a disappointingly pale sky.

The first step is to define a very precise selection using the Select⋯Color Range command. The object of the selection is to pick up only the sky-blue areas of the image, leaving white-cloud highlights unaffected.

Step 2

In the Color Range dialogue box, click on the Select drop-down menu and choose the Sampled Colors dropper tool. Make sure that you've also got the Selection preview option checked, found under the tiny image preview window.

The Selection preview should be black as shown above. Place the Sampled Colors dropper tool into your image window and click on the darkest area of blue sky. The areas in the black preview window that appear whitest will be included in your selection.

Step 3

Next, move the Fuzziness slider and watch how different areas become included or excluded from the selection. Aim to keep any white-cloud highlights black in the preview image. Once you are happy with your selection press OK and return to your image.

Above shows an ideal selection, where highlights are left outside any future manipulation. If this process hasn't worked, go back to the Color range dialogue and repeat it until it looks right.

Step 4

Next, from the toolbox pick the dropper tool and click this onto the richest patch of blue in your sky. Watch how the Foreground colour will change to reflect this. Now, to make this blue a bit darker than it was originally, double click the foreground colour square and enter Photoshop's colour picker dialogue, as shown above. Instead of picking an unrelated colour at random, press and hold the Arrow Up key on your keyboard and watch the current colour circle move into darker zones.

Armed with the right colour, now choose the Linear Gradient tool and set it on Foreground to Transparent mode. Place your cursor at the top of the image window and click-drag the gradient line inside the selection area. If it looks odd to start with, experiment the length of click-drag and also the direction.

This example to the right had a very small gradient applied to make the blue sky look a bit less washed-out.

Converting to monochrome

Converting colour images to monochrome can be just as disappointing as printing colour negatives on black and white photographic paper. Here are two methods for much better results.

The original image

Some images look much better in black and white, but you only come to that realisation after returning from the shoot. With digital colour manipulation, it's very easy to reinterpret your colour images in monochrome if you avoid the easy methods.

With complex conversions, the digital process is similar to shooting black and white film with deep colour contrast enhancing filters like the landscape photographer's favourite, red 25A.

Straight conversion

Converted from RGB colour mode to Grayscale mode, the resulting image lacks any kind of punch. Bright colours in both sky and the land have translated badly, leaving a muddy and indiscriminate image with little tonal separation. Looking like a photographic print on a low-grade paper, all emphasis has been lost.

Exactly the same results occur when an RGB image has its colours drained away using the Image····▷Adjust····▷Desaturate command.

Converting to LAB mode

A better way to avoid muddy midtones is to convert your RGB colour image to LAB mode. LAB, unlike RGB and CMYK, keeps its colour channels separate from its brightness channels.

After converting, click on the Channels palette and drag both A and the B channels into the Layers wastebasket.

You'll notice immediately that your image looks brighter. Convert back to Grayscale before printing out, or back to RGB for toning.

Using the Channel mixer

The most creative way to make your own individually styled conversions is to use Photoshop's Channel mixer. Found by making an Image····❯Adjust····❯Channel Mixer command, the dialogue box offers you the chance to remix original image colours.

You can achieve lots of different results, too numerous to mention in this book, but it can be like reshooting your colour images with a specialised black and white routine like infra-red or deep-red 25a filter.

This example to the right, was created by mimicking the effect that a deep-red filter has on a dark-blue sky.

Using the dialogue box

To make a creative conversion, make sure you click on the tiny Monochrome check box first, shown below in the bottom left-hand corner. Next decide which colours you'd like to emphasise and decrease their values to darken their appearance or increase their values to lighten. Keep a watchful eye on the numerical values appearing in the Red, Green and Blue Source Channel text boxes, as they must collectively add up to 100. The Constant slider works like a crude exposure control.

Cyanotype print process

Cyanotype prints suggest a part-object, part-image, far too delicate to remain in the light for any length of time. The digital version, however, is much more stable.

The cyanotype process was invented by Sir John Herschel in 1842 and was a cheap and effective way of making images without the use of a camera. The process was adopted by Anna Atkins, whose study of flowering plants left us with a set of delicate photogram-like blue prints. Cyanotypes were an iron process (like platinotype) avoiding the use of silver and were also printed out. It also became known as the blueprint, surprisingly remaining in use this century for the reproduction of large architectural drawings before the advent of photocopiers. The process was largely forgotten when blue toners were introduced for use on conventional gelatin silver papers.

Making a Cyanotype Image

Lie a sheet of clear acetate over your flatbed scanner to prevent it from getting scratched and make an arrangement of natural objects, the same way you'd make a photogram. Scan this as a low-contrast grayscale. With what appears to be a rather flat and lifeless image, in Photoshop, do an IMAGE-ADJUST-INVERT and watch your positive image change to a negative and resemble a simple photogram. Introduce the cyanotype colour by making an unconventional tritone: change the image mode to IMAGE-MODE-DUOTONE and select TRITONE.

Selecting the colour

To nominate a colour, click on the Ink Colour boxes, then click on the CUSTOM button, choosing the PANTONE COATED colour library. Scroll through the palette until you find a suitable colour and click on it. If you position this control box to the edge of your screen, you can preview the effect of each colour change on your image. If you already know the three colour codes, just type the code in and Photoshop will find the colour for you.

To mimic the cyanotype colour, make a tritone image and replace the black ink with PANTONE 2728 CVC, using PANTONE 2718 CVC and PANTONE 290 CVC as the second and third colours. Precise control over the tonal areas in which you want these colours to appear is controlled in a DUOTONE CURVES dialogue box, shown by a simple graph to the left of your ink colour. Here you have the option of determining whether certain colours lie in highlights and midtones only, or are represented across the whole scale. It's a bit like deciding that your selenium toner is only going to show in the midtone areas of your black and white print. It can be used to great effect, the outcome of which can be viewed immediately. Choose the Curves dialogue box for the third ink colour and type in 50% at the 0 box and 0% at the 50 and 100 boxes, making the pale blue present only in the highlights.

Printing out

There's no reason to change the image mode before printing out, but there are lots of Pantone colours that your printer just can't reproduce. Print out on matt coated inkjet paper for sharpest results, or Somerset for a textural effect. Make a test strip first to judge the conversion. Large-size single-colour prints like this example (right) can drain all the cyan ink in one cartridge after one print!

Chapter 9
Unconventional Media

⋯▷ Mono on uncoated papers

⋯▷ Colour on uncoated papers

⋯▷ Making books and albums

⋯▷ Pre-printed and ephemera

⋯▷ Using artist's papers

Mono on uncoated papers

Uncoated papers offer the photographic printer a completely new experience. With different textures, base colours and thicknesses, this kind of media is a challenge to use properly.

Made for the commercial printing industry, litho papers can be bought cheaply but rarely in small quantities. They are best sourced directly from paper dealers, who will send you a swatch book and sell you a sample pack once you've decided on a material to try.

The most interesting papers include those with textured surfaces or made with composite fibres which add a totally different look to your images. Litho paper is designed to be used with spirit-based inks, rather than the water-based inks of an inkjet printer. However, despite a slight loss of image sharpness due to the spreading of ink droplets and a lower than expected colour saturation, very good results can be achieved.

Media limitations

It is important to recognise that this type of material will react very differently to standard bright-white inkjet media. Firstly, it is more absorbent and less reflective, so your first test prints will be disappointingly dark and have a muted colour range. It will also be impossible to reproduce pin-sharp detail, so only use on those images that have a healthy degree of creative defocusing.

Contrast too will seem problematic as the base colour of the litho paper will become the highlight colour of your image, so an image printed on cream paper will have cream-coloured highlights. Don't expect your inkjet to print white!

The illustration below shows the same image printed onto three different coloured papers. On the left is a standard bright-white inkjet paper, which reproduces the image as a well-adjusted photographic print. The middle swatch is a piece of Conqueror writing paper, yellowish in tone, which takes the highlights down. On the right is a sandy-coloured Gmund Bark lithographic paper, which takes the highlights down even more. Even after fully correcting the brightness of each image, the highlights will only be as bright as the paper's base colour. Colour balance too will be influenced by paper base, so you might want to make an adjustment before sending to print.

Preparing your image files

It's not important to have extremely high-resolution image files to print from, as litho paper can't cope with 1440 dots of ink per inch. As ink dots spread slightly once they've hit the paper, like ink on a piece of blotting paper, you won't see any advantage using images above 150 ppi. If you reduce your image resolution from 300 dpi to 150 dpi, they'll be leaner to store and take less time to process and print too. Make a copy of your image file and reduce your image resolution in Image Size dialogue box, by resampling down to 150.

Setting up your printer

Many litho papers are manufactured beyond a printer's maximum media thickness of 300 gsm. If you've got an Epson printer, make sure you move the tension lever (found under the printer lid) from '0' to '+', to accommodate these thicker materials. Paper misfeeds are an annoying problem with non-standard media, but can be easily solved by pre-positioning in the print rollers before you send your image file. Press the Form Feed button on your printer and watch your paper being pulled into place.

Setting up your printer software

Even though your desktop inkjet can produce convincingly sharp photo-realistic prints, you won't need to use any of its high-quality features. As always, make test prints of your images to see which settings work best and to save materials and ink. As a rough starting point, try Plain Paper as your selected media and experiment with 360 and 720 dpi printer output. As the paper is absorbent, ink droplets will bleed into each other.

First test print

Above shows the most likely result: too dark, loss of sharpness and a bit of a disappointment. This image was printed on Svecia Antiqua, a machine-made paper designed to look like handmade stationery. The result is too heavy: despite the image looking good on the monitor, all the midtones have fallen into the shadows.

Adjustment in Photoshop

To make the image print brighter, very like reducing the exposure time using the enlarger, all you need to do is to move the midtone slider to the left in your Levels dialogue box. The image will now look much brighter than you are used to seeing on your monitor, but stay with it.

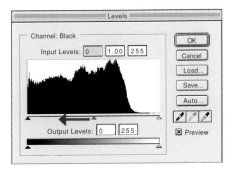

Final print

Above: after a Levels adjustment, the image now prints much better with more shadow detail and the laid paper texture showing through. Because the paper has a creamy off white colour, it gives the image a warm-toned look. If you want to counteract the effect of the paper base colour, use your Colour Balance controls to add or take away the cast/tone.

Colour casts with grayscale

Surprisingly, printing grayscale images using all of the six colour printer inks may lead to a colour imbalance. Unknown chemicals in the paper coating may lead to a slight colour shift, even though your image is neutral and in grayscale mode.

Printer maintenance

Paper jams and misfeeds are inevitable, but make sure you remove spilled ink from the carriage with a lint-free cloth. Stray pools of ink in your printer will always mark your work, even once it's dried out. Use roller clean-up sheets, like those supplied with the Epson 2000P, to remove accidental ink spills or sheets of cheap uncoated inkjet paper.

Other media

Good-quality writing paper like
Conqueror and Svecia Antiqua Rare
make good-quality printing material.
Without a coating of size to stop ink
and paint marks bleeding into each
other, this material holds finer detail
better than most artist's watercolour
paper. Stationery is a great material for
making individual sections of your own
handmade book. Recycled paper too,
like Gmund Straw, is made with bits of
straw and fibre showing through the
surface. There's a random and
unexpected nature to using this kind of
material, but that's part of its attraction.
For this image (top right), finely
detailed leaves and fabric were scanned
in on a flatbed then printed out.

Overprinting

Like traditional artists' screen-printing
and litho processes, you can use the
overprint technique with an inkjet.

Feeding the same sheet of paper
back into the printer to be used again
will give you random registration
effects, when images overlap and
create double ink density.

This image (below right) was
produced by feeding the paper in five
times. Although precise registration is
near impossible, accidental results can
add a different twist to your working
method.

Of course this is the ideal way to
combine several different kinds of art
printing processes like silkscreen,
monoprinting and etching – all on the
same sheet of paper.

Colour on uncoated papers

Don't expect vivid colours when printing with artist's papers – instead aim for a more delicate and subtle result.

The next major issue when printing onto uncoated non-inkjet papers is the loss of colour saturation. Many papers will suck the ink straight below the surface and with it any saturated colour effects. This is no different to the variation in tonal reproduction between matt and gloss photographic papers, but you can go some way to correcting it in Photoshop.

The first colour print

This image below was printed onto a sheet of Indian handmade writing paper. The paper was very thin and highly textured, so the image lost a bit of its fine detail. The first test print emerged from the printer very muted. As the creamy base colour of the paper dulled the highlights, it also reduced the intensity of the blues and pinks.

Adjustment in Photoshop

To counteract the loss of colour saturation, return to your image and go to Image····⟩Adjust····⟩Hue/Saturation. Now move the Saturation slider to the right. As when using the Levels adjustment to make your print brighter, don't be afraid of pushing the Saturation further than you would normally. On your monitor, it will look very bright and overcooked.

Final print

Compared to the first print, the final print (below right) now looks much better and not as overdone as your monitor image. Accepting that the paper will take the edge off overcooked image adjustments can be a nervy experience if you've got great trust in your precisely calibrated monitor.

Hand finishing

As inkjet ink is water-soluble, you can apply a wet paintbrush to your print for additional softening of detail or bleeding. This works best for cut-outs or images against plain backgrounds. If using a brush is your thing, you can also apply watercolour paint to create a truly hybrid beast: the photo inkjet painting.

Print quality declines

Occasionally when printing onto heavily textured papers, your printer head will misregister or become blocked. Printer head cleaning and realigning is a simple process that can be controlled via your printer software dialogue box. If quality is still poor, then you need a new ink cartridge.

Making books *and albums*

Providing you use the right kind of paper, you can bind inkjet prints into handmade books.

All the specialised bookbinding materials needed to make a simple flat-back casebound book can be bought from a specialist bookbinder's suppliers. Of course you don't have to print on inkjet paper, but if you choose to, you'll get much sharper results and higher colour saturation.

Two good papers to try are Somerset Velvet Enhanced and Lyson Fine Art; both have a highly tactile surface without sacrificing print quality. For larger books or unusual page sizes, you can order these materials in roll format which can then be cut into custom page sizes. Of course, the thicker your material is, the thicker your book will be, so opt for 150–225gsm weights instead of full-on 300gsm and it'll also be easier to fold.

The next consideration is the material used for stiffening the covers, called strawboard, which won't warp after absorbing glue and can be cut into strong shapes without bending. To cover the backing board, you'll also need some bookbinding cloth. Pre-sized with glue, it provides a protective outer skin and stops dog-eared corners. Linen tape for strapping the weighty pages to the book covers is also essential.

A full list of equipment, materials and suppliers for this kind of bookbinding project is given in the Reference and Resources section at the end of this book.

Planning

Start off with a simple project like a book to hold fourteen images. For this project you'll need eight A4 sheets of quality inkjet paper, but don't fold it at this stage – do this after printing. To help you visualise your page sequence, use photocopy paper to make a mock-up dummy book first.

Fold the copier paper and assemble it into four individual sections (by slipping one folded page inside another). Next, mark page numbers, text and image placement in pencil. It's a good idea at this stage to appreciate that you'll need to be extra careful when printing your images onto the right sheet of paper! You'll be printing onto both sides of the paper, so it's important that your planning is crystal clear before printing commences or you'll run into complications. Your picture plan should look like the illustration to the right. Greyed-out numbers show images printed on the reverse.

The next stage is to prepare your image files to the right size and resolution for your paper. If you are working from high-resolution files, chop them down to exactly the right dimensions, as this will make printing out quicker. To make things even more logical, rename your image files with the page number they will appear on, e.g. 1.tif, 2.tif etc.

Printing out

You don't need QuarkXpress or another programme just to position your images. There are two cheaper, but unconventional ways of approaching this problem: firstly by using the printer's own software to position the image on the paper, or secondly by using the latest version of Photoshop. If you do have Photoshop 6.0, the process is very simple.

For Photoshop 6.0 users

In Page Set-Up, choose A4 paper size. Next choose File⟶Print Options and select Show Bounding Box. Now deselect Centre image and move your cursor over the image icon. Now just drag the image into position on the right half of your sheet. Use the Position indicators if you want to be exact.

Pre-Photoshop 6.0 users

If you haven't got Photoshop 6.0 or if you've got an older Epson inkjet printer, your best option is to use the printer software. This is a slightly more complicated route as you have to flip your image before printing and then fool the printer with a custom paper size.

Open your image file in Photoshop and do Image⟶Rotate Canvas⟶180, then select Page Set-Up. Create a custom paper size that is exactly half the size of the paper you are destined to use, if using A4, make it Width 21 Height 14.5cm. Name and save this setting. Next go to Print and choose your new custom paper size, plus the Centred option and most importantly Landscape orientation. This is to trick the printer into positioning your image centrally, but only on the right-hand side of the paper. As your A4 paper is fed through the printer, the remainder will be ejected once printing has finished on the smaller custom size.

To print out preceding images on the same sheet, i.e. on the other side of the paper, open the image in Photoshop and rotate it as before. Load your paper into the printer so the previously printed side is face down and at the opposite end to the printer feed, then print. It's a dead certainty that you'll make a mistake at this stage, so do a trial run on some copy paper first just to see if you're doing the right thing.

When you are ready to print out using good paper, mark the page numbers on your inkjet paper lightly with a pencil, so you know which one is which. Refer to your dummy for guidance and print out all the pages. If your images occupy most of the page or are heavily toned, leave to dry first before printing on the reverse side. This kind of book design uses images opposite blank facing pages, but if you want to double your printed images, i.e. printing four per sheet, be careful ink doesn't seep through and ruin it.

If you want to print text on the opposite leaf to an image, open Photoshop and make a new image with dimensions and resolution to fit. If you are using a pre Photoshop v6.0, the resolution will need to be set to 300 dpi for pin-sharp text.

Binding

The next step is to fold your sheets, but first you need to mark the exact centre on each. Rather than mark the paper with a pencil, use a pin to prick halfway at top and bottom points. Now, with your metal ruler, line these points up and lightly score the sheet with the blunt edge of a scalpel or Stanley knife. There's no need to press hard and neither should there be evidence of a cut. Next, gently fold your sheet inwards and use the bone folder to press firmly on its spine. Repeat on all sheets and then assemble them

▲

Individual sections, before folding, should look like this.

into four sections. Be careful at this stage that each page is completely dry; if in doubt, press a sheet of copier paper over the images.

Next, you need to use a strong darning needle and prick six holes through the spine of each section. Mark out on a piece of card the distance between each hole and use this as a guide for pricking out. Position the book on the edge of a workbench and drape two cut lengths of linen tape, about four inches, over the spine as shown overleaf. Tape helps to support the weight of the pages and, although this book is relatively small, should always be used with more ambitious projects. Next, with some strong cotton, stitch the sections together as shown below.

Tie the thread tightly and cut off the excess. Clamp the sections tightly between two boards, and cut a piece of gauze-like mull to fit. Apply this to the spine with PVA. You shouldn't move the book until this is dry, so leave it for a couple of hours. Once dry, cut a piece of brown wrapping paper exactly the same size as the spine and glue this on and leave to dry.

Next, choose a coloured endpaper, such as Ingres paper from an art shop. Cut into two A4 sheets then score and fold to make two A5 sections. These will be used to attach your pages to the cover. Offer the pages up to the book to see if they are the right size. Next, apply glue to an inch-wide strip running parallel to the fold. Press this sheet onto the first page of your book, leaving mull and linen tapes outside.

Covering

Now you need to measure the book for front and back covers. Allow an extra 3mm around top, bottom and opening edges, but take off 5mm from the spine edge. Place the boards around your book and take the combined thickness as the measurement for the spine strip. Cut a final piece of board for the spine strip and sand down any sharp edges with fine glass paper.

Next choose a piece of cloth to cover your boards with. If you want to use normal cotton cloth or linen, iron the cloth and then coat with a weak solution of PVA to stiffen it up. Lay the boards on the cloth, not forgetting the spine strip, and cut the cloth leaving a 1 inch gap around the outside. Use your metal ruler to position the boards in place on the reverse of the cloth, leaving a 5mm gap at both edges of the spine board. Draw around the perimeter of the boards with a pencil, lightly marking the cloth.

Next, apply glue to the cloth, brushing from the middle outwards and work quickly. Place the back board on the cloth then place the book on top. Align the spine strip and then place the front board on top too. Next wrap the cloth around the spine and front board, pressing firmly as you work.

Remove the book and lay the board and cloth flat on your worksurface. Use your bone folder and make sure the cloth has adhered to the boards properly. Next tuck in the corners and turn in the excess cloth as shown below.

Once complete, leave the cover to press overnight. Sandwich between two sheets of sugar paper to absorb any excess moisture. Don't be tempted to work on it if the boards are not dry, as they'll warp.

Assembly

Finally, you need to attach the book to its cover. Remove the cover from the press and lay it flat on your work surface, cloth side down. Pick up the book and place an oversized sheet of sugar paper between the endpaper (coloured) and the inkjet paper to prevent glue spoiling your book.

Apply glue to the outward-facing endpaper, coating mull and linen tapes too. Replace the sugar paper with a new sheet, then pick the book up and lining it up with the spine, press it firmly down onto the cover. Next coat the other endpaper and repeat the process. Leave to press for five minutes then remove. Use your bone folder to smooth out any wrinkles or parts of the endpapers that have come away.

Remove the sugar paper and place new sheets between the endpaper sections and press overnight. Finally, it's a good idea to keep it pressed for a couple of days, replacing the sugar paper each day to prevent any moisture from warping your hard work.

Pre-stitched books

Another approach to assembling your prints into personalised books and volumes is to use a blank. Unpick the stitching from an artist's sketch pad or notebook and print on the pages. There's no cutting or folding to do and you've got the stitch holes to use when you put the book back together. This example (right) was printed on a small artist's sketchbook bought at a car boot sale, which had all the signs of age and wear and tear built in.

Making albums

If you want to present your images on specially bordered paper, you can print the border on the same sheet of paper as your image. Instead of sticking your print onto an album page, make your print and album page one and the same thing. Below is an example of a hand-made album made by printing a special dull green as a border, to emphasise the warm toned print.

Pre-printed and ephemera

There's no reason to limit your printing experiments to brand-new paper, as pre-printed paper and ephemera present the opportunity to make something very unusual.

Good sources to try

Found in the bargain basket in any secondhand bookshop, torn and broken books can provide unusual paper material for printing on. With random words or illustrations providing an unconventional background texture, these papers can add another layer to your images.

Look for older examples, typified by a stitched spine, as the quality of paper will be higher than the low-grade pulp of an ex-airport novel.

Many old letterpress-printed books, identified by the slight indentation that each letter makes on the paper as a result of the pressure of the metal type, are usually printed on excellent cotton papers which have already passed the test of time. Bond or laid papers used in old letterpress books will have been made with little or no harmful coatings.

Invisible coatings

Look for natural, uncoated paper sources as a shiny or ultra-smooth material will be impregnated with unknown chemicals and hidden ingredients that will stop your ink from being absorbed. Any material that has been given a colourless high-gloss varnish, like most modern packaging, won't absorb ink in the slightest. Pages from illustrated books that were made with crude printer's line or blocks can also provide a fascinating material to use.

Practical problems

Printing on an unknown material will usually present similar problems of low print sharpness, low colour saturation and darker than expected printouts. As a rule, try and perform your test prints on a piece of paper from the same source and if they are limited in supply, make small custom-sized pieces out of a larger sheet. To prevent your paper from becoming waterlogged with more fluid than it was originally intended to cope with, make a lighter than normal image and reduce your black point using Levels.

Printer maintenance

Try and ensure that any material you use doesn't compromise the finely balanced print heads. Avoid feeding irregular shaped media; instead, rip it into shape after it has emerged.

Using artist's papers

Purpose-made artist's papers for watercolour, printmaking and etching offer an unusual alternative to high-performance inkjet media, but getting good results can be less than straightforward.

Practicalities

Unlike off-the-shelf inkjet media which are designed to work seamlessly with your printer software, artist's papers are designed to be painted, printed or drawn on.

The primary issue concerns the paper coating, which unfortunately remains invisible to the naked eye. The only way of detecting the extent of the problem is to print a test strip.

Inherent limitations

Before starting it's well worth running through the downside to using artist's papers. Firstly your results won't be pin-sharp because of the open texture and the absorbency of the paper. Tiny ink dots will not mesh together like they do on a flat, uniform surface.

With an increase in paper absorbency, ink dots will seep beneath the surface and reduce the intensity of colour reproduction and produce a much compressed tonal range.

Inherent qualities

Without dwelling on the negative side, artist's papers offer a more tactile experience, combined with a greater range of paper base colours and edges. Excellent for binding into books, many papers have an identical coating on both sides. Papers bought in single sheets often have a deckled edge, making the media feel like an artwork before you've even touched it.

Image resolution

As the paper material is very absorbent, you can reduce your image resolution drastically. With ink dots merging into one another on the page, experiment by dropping your resolution down in steps of 20 from a 200 ppi starting point. On some very absorbent papers, you can drop to as little as 100 ppi.

Problems with bleed (right, top)

If the art paper has little or no size, like blotting paper, areas of heavy inking will start to bleed into one another. To prevent this from happening, use your Levels controls to make the image lighter before sending to print.

Problems with size (right, bottom)

Size is a transparent fluid used in paper manufacturing to stop paint spreading. This example shows how high levels of size can interfere with the even distribution of ink. Small white specks of paper show through the ink, particularly noticeable in the midtone to shadow areas.

Good papers to try

Available from all good art shops, these papers will repay time and effort.

Fabriano Rosapina

60% cotton, acid-free, two deckle edges available in white or ivory. 220 or 285g/m2. Watermarked.

Arches 88

Unsized 100% cotton, mould-made paper with four deckled edges. 300g/m2.

BFK Rives Blanc

100% cotton, acid-free and from 180–250g/m2. Watermarked.

Chapter 10

REFERENCE AND RESOURCES

----> Print quality problems

----> Large-format inkjet printing

----> Removable media care

----> Recommended papers

----> Lightfast and fading issues

----> Internet printing services

----> Profile suppliers

----> Equipment supplies

----> Software resources

----> Photocollege web resources

----> Cataloguing your images

----> Storage and presentation

Print quality problems

Despite sophisticated printer software, there are plenty of common problems that occur when you least expect them to.

Puddling

Caused by choosing the wrong media setting in your printer software dialogue. Pick a lower-grade media setting to correct this.

Ink running

Caused by choosing the wrong media setting when using plastic film or high-gloss paper media. Try a lower-grade media setting to correct this.

Unsharp

Occurring when using uncoated papers, too much ink has caused a loss of sharpness. Increase image brightness using the Levels slider. See pages 124–125 for more details.

Thick banding

Caused when printing with uncoated or artist's papers, especially when using high printer resolutions like 2880 or 720 dpi. Experiment with lower printer resolutions such as 720 or 360 dpi.

Ink run out: yellow

This kind of problem occurs when one of the ink reservoirs runs dry during printing. In this case, yellow has stopped printing, leaving a colour imbalance on the bottom half of the print.

Ink run out: cyan

The same problem, but this time caused by the cyan ink cartridge running out.

Ink run out: black

This problem makes a dramatic impact on image contrast, and is caused by the black ink cartridge running out.

Printing with black ink only

This happens when printing monochrome images using the black ink setting only. Better results are achieved using colour inks.

Pixellated prints

If you can see square pixels on your print, it's caused by a low image resolution. Check your image size, or rescan, or print your image smaller.

White horizontal lines

This is caused by blocked individual ink nozzles. Go back to your printer software and do a printer head cleaning routine.

Blocky print

This is a result of over-enlarging a low-quality JPEG file. Print smaller or rescan or reshoot if practical.

Speckled print

Caused by printing out at too low a printer resolution. Change from 360 dpi to 1440 dpi and reprint.

Wrong ink cartridge (right)

Perhaps the most unusual print problem the author has ever encountered was caused by using the wrong ink cartridge. The arrangement of inks pods in the ink cartridge differs from printer to printer. By instructing the right pods filled with the wrong colour to print, a radically different colour mix was produced in error.

Large-format inkjet printing

With prices dropping steadily, a large-format inkjet printer offers the chance to reproduce your images on an enormous scale.

A large-format printer like the Epson Stylus Photo 7500 uses rolls of paper up to 24 inches wide and can make A1+ sized prints. Using the familiar Epson printer software interface, there's very little difference in approach. Of course, there will be a proportional increase in data size for such large printouts, but not as large as you may think. Used by many in-house graphics departments, a large-format printer can be networked or left as a stand-alone device with or without a raster image processor.

RIP or not?

Two types of raster image processor are available for this type of printing device: a software RIP and the much more expensive hardware RIP. Essentially a device for converting vectors shapes like type and graphics into a form the printer can understand and output, RIPs will also speed up the printing process. Users who print mainly pixel-based photographic images do not need to use either.

There's no need to buy a hardware RIP unit to run a large-format printer (which can double the cost of your purchase) if you intend to run it from a dedicated computer terminal rather than a network.

As image data files will be on the large side, your computer needs to have a fast processor and enough memory to spool the largest file you are likely to print.

Preparing your image files

Large-scale paintings like ceiling-bound frescos look disappointingly coarse when viewed close-up. This is because they were never designed to be seen at such close quarters, letting journeymen fresco painters skimp on detail.

Every painting and photograph, regardless of its size, has its own particular viewing distance. Small pieces, like miniature portraits, are intended to be viewed close up, but larger wall-mounted images are best viewed from a greater distance away.

Therefore, when preparing your image files for print out on such a large scale, you can afford to reduce the normal inkjet pixel resolution of 200 per inch to between 150 and 170 per inch. The pixels are reproduced bigger than normal, but because you are standing further away, you cannot detect the drop in sharpness.

The most useful by-product of this is that you do not have to capture super-high resolution for large-scale printing out. With even the lowest-resolution flatbed scanners capable of capturing 24Mb of 24-bit data and film scanners around 30Mb, there's easily enough to make an A2 print.

With a little judicious interpolation up to 40Mb, followed by careful USM sharpening, an A1 sized printout is within easy reach. Flatten your image before sending to print for a quicker turnaround.

Sending out to a bureau

If you decide to send your images to a bureau for special large-scale output, follow these tips for best results:

1. Contact the bureau beforehand to establish which working colourspace they use. If it's different to the one you use, consider changing over just for this task.

2. Find out what is the ideal resolution for the print size you are aiming for. If your image file is too small, your print will look unsharp result. If it's in the 300–400 dpi range and well beyond the limits of your desktop equipment, consider having a high-res professional drum scan made instead.

3. Supply a good-quality A4 proof for colour matching and convert any duotones into RGB mode first.

4. If your artwork contains text, either flatten the layers or supply both screen and printer fonts on your disk. Only flatten the image if you are certain of matching the ideal resolution.

5. Don't compress your image file as a JPEG if you want to get the best-quality results in return.

Removable media care

Despite the all-embracing increase in digital data storage, there are a few precautions you should take to ensure disks and their valuable contents are not damaged beyond use.

CDR and CDRW disks

Avoid the following:

Temperature: Do not expose the disks to prolonged direct sunlight.

Liquids: Do not immerse in any liquids, even water.

Adhesives: Do not attach any adhesive tape or use any liquid adhesives to stick labels onto the disks. Only use manufacturer's recommended labelling products.

Writing: Do not write on the shiny side. Only use special CD pens to write on the label side. Never use hard points like pencils or ballpoints.

Zip disks

Avoid the following:

Temperature: Store your disks away from the extremes. Keep them between 50C and –22C.

Liquids: Do not immerse in any liquids, or expose to rain.

Magnetism: Avoid all sources of magnetic fields such as hi-fi speakers and electric rail transport.

Handling: Never retract the metal shutter at the top of the disk and touch the exposed media.

Writing: Avoid using hard points on the label.

Floppy disks

Avoid the following:

Temperature: Keep your disk well away from direct sunlight and between the temperatures of 52C and 10C. Never leave them on a window ledge or near a radiator.

Magnetism: Avoid all sources of magnetic fields such as hi-fi speakers and electric rail transport.

Handling: Keep disks away from dust and all liquids. Never touch the internal disk.

Writing: Use only soft-pointed pens rather than pencils.

Recommended papers

There are lots of inkjet media products on the market but only a few papers that produce consistently high-quality results.

Somerset Enhanced

Somerset, a paper brand associated with fine-art printing and from the same stable as Bockingford and Saunders papers, has developed the most sensational material on the market so far.

Somerset Enhanced is available in three surface finishes, Satin, Velvet and Texture. It's 225gsm 100% cotton paper with an acid-free base sheet, so it looks and feels like an artist's handmade paper. With a special invisible coating, it creates pin-sharp prints at the highest printer resolutions, unlike traditional artist's materials which were never intended to cope with the fine dots of an inkjet.

With outstanding colour reproduction, even of saturated hues, this paper is produced to high archival standards.

Without spreading and losing sharpness, the texture of Somerset Enhanced reduces any visible signs of inkjet dot. Somerset is available in A4, A3, A2 and roll sizes.

Lyson professional media

Lyson, like Somerset, is another UK company that has excelled in the production of custom inksets and papers to meet the high demands of professional photographers and designers.

In an extensive paper range that includes old favourites like photo glossy, lustre and matt finishes, the most exciting medium is the Lyson Standard Fine Art, weighing in at a heavyweight 310gsm.

Similar in performance to Somerset Enhanced, this paper works well at high printer resolution and is capable of a reproducing a wide tonal range and saturated colours. Sharp image detail is well preserved, which is unusual for a semi-textured and non-glossy paper. With a good separation in the shadow areas, this paper will cope with both high- and low-key subjects.

Lyson Soft Fine Art is another interesting material which has a mottled rice-paper-like translucency. Lyson's 300gsm 100% Cotton Rag is also well worth a try if you like the look and feel of handmade paper.

Lyson supply free output profiles for all their media; more details can be found on page 146.

A most useful addition to your purchase is the Lyson User Guide video, a comprehensive step-by-step programme which covers setting up profiles in Photoshop and printing out tips.

Epson media

Designed and calibrated to perform at top quality with matching Epson inksets, the extensive range of papers are a good choice for newcomers to digital printing.

Very good value for money, Epson media are naturally designed to work seamlessly with Epson printers and printer software and, providing you pick the corresponding media settings, results will be near perfect first time round. For the newcomer to digital printing this range of media offers good results without too much trauma.

In response to a growing demand for heavier weights and more tactile finishes, the latest archival media, such as Archival Matte and Semi Gloss paper, are well matched with the professional pigment-based Epson 2000P printer.

Many unusual media types are available, including glossy films, backlight media and self-adhesive papers that extend the use of an inkjet printer into the business and office market.

For general-purpose printing the standard Epson Glossy Photo is available in different weights, but at a cost comparable to budget brands, there's little point in using anything else.

Early Epson papers were not immune from criticism regarding fading and very short-term life expectancy, but the latest media, coupled with Intellidge or pigment inks, perform much better.

Lightfast and fading issues

The Wilhelm Research Unit has established itself as the leading independent voice on the lifespan and stability of inkjet papers and inks. While manufacturers will always present their products in the most favourable light, independent research often shows otherwise.

Independent scientific research

Tucked away in a little-known website is the highly influential Wilhelm Imaging Research.

Established to monitor and evaluate the lifespan of inkjet media through a series of simulated but objective tests, results are posted on a frequent basis for most new printers, inksets and papers.

This is a useful site, particularly for professional photographers who need to have confidence in their choice of media, used for commercial purposes. In the early days of media development, WIR were instrumental in alerting users to papers which had an alarming tendency to fade in a matter of weeks.

http://www.wilhelm-research.com

Fade factors explained

There are several obvious and not so obvious factors that link directly to the lifespan of an inkjet print.

Media quality

Cheap inks and paper are not designed for professional photographic use and not designed to last. Cheap dyes fade quickly and cheap paper is usually made with bleaching agents.

UV exposure

Placed in direct sunlight, no print, be it an inkjet or lightfast litho, will last for ever. Art galleries usually display work behind diffusing blinds or screens to soften and limit the effect of UV damage.

Atmospheric pollutants

The destructive effects of ozone and high humidity have been known for some time. The latest media have a 'swellable' top coat which can accomodate a certain amount of airborne moisture.

Early products

Early inksets and media by Lexmark were found to change significantly within a year of printing. Early products by HP suffered a similar fate, but with a slightly improved lifespan of three to four years. Both manufacturers' products have now dramatically improved in recent releases.

Extending print lifespan

As with the storage and display of photographic prints, there are some common-sense methods for keeping your artwork in top condition.

Adhesives

Never use any spray, contact or PVA adhesives to mount your prints, as chemicals will seep through the back of your print paper and react with image dyes or pigments. Avoid also any heat-sealing or dry-mounting processes. For more information on safe mounting and storage methods, go to page 150.

Light and air

If prints are to remain on permanent display, avoid situating in direct sunlight and directly under bright artificial lights. Frame behind glass and use a water-based adhesive tape to make a moisture proof and airtight seal between frame and backing board.

Mounting materials

Acid-free mount board is easily available from professional photographic stores and art shops and will prevent the corrosive chemical action of cheaper mass-produced card. Although the effects of such chemicals are slow to present themselves, you can't reverse damage once it's occurred .

Internet printing services

Another way to print your digital photographs is through an Internet-based photolab. Simply upload your image file to the website and wait for your prints to be returned through the post.

Everyone at some stage has attached an image file to an email and sent it to a friend, and the latest method of printing digital images uses the same principle. With no need for a desktop printer, you can attach your camera to any Internet-connected computer, select the images you want to print, then upload them to an Internet lab.

Waiting at the other end is a digital output device like a Fuji Frontier connected to a server. When your files reach their destination, they are laser imaged onto conventional photographic paper, then posted back to you.

Costs are very reasonable, with high-quality prints pitched at a cheaper price than machine-made prints from a professional lab, but with a quality to match a handprint. With no lens to lose focus or dust to mark your prints, quality needs to be seen to be believed.

Compression and transfer time

Of course, the larger your image files are, the longer they will take to upload and the higher your telephone bill will be. The temptation is to compress your data for a fast upload, but results will be crude. Do use the JPEG routine to compress your files, but only use high quality settings like 8, 9 and 10 or 80% to 100%. Many Internet labs also restrict uploads to certain file formats only, like JPEG.

Image resolution

As a general guide, prepare your images at 200 dpi to avoid any visible signs of pixellation on your prints.

Image dimensions

Digital-camera sensors rarely correspond to conventional photo paper shapes or film formats. In practice, they are slightly wider, resulting in cropping when printed to 6x4 photographic paper.

Highlights and shadows

Unlike straight machine prints made from negative or transparency film on a lens-based mini-lab, laser-imaged prints don't sacrifice highlight detail for shadow detail (or vice versa). Digital files do not have dense areas that need to be coaxed out, only brightness arranged over three 0–255 colour scales. Providing your original files don't have any 'detail holes', they will print without problems.

Lab processing

Once received, lab software will apply a range of processes to your images, such as USM sharpening, colour balancing and brightness/contrast. If your enlargement request exceeds the resolution of your image, it will be resampled accordingly and may lose sharpness. Follow the specific guidelines prepared by each lab for best results.

Fotowire.com is a major internet photo printing service with a presence in over twenty countries worldwide.

photobox.co.uk has gained a good reputation for high-quality output and free storage. Images need to be uploaded via an ordinary browser.

*Kodak Picture centre is an innovative
service including online software tools
for applying creative colour and sepia
filters and wacky distortions.*

*Fotango.com is a postal film-process service
that includes a free upload to the Fotango
site. Films are organised into albums
(above, bottom) and individual images can
be viewed at a good size (above, top).*

Upload and storage

Many Internet-based labs give you a
password-protected storage area to
keep your digital files on a remote server.
Many different arrangements exist, but
typically some labs charge you for this
facility. Some delete your work after a free
period, but Photobox gives you 50Mb
unlimited free of charge.

Sharing your photographs

The advantage of having a remote storage
facility also varies between each supplier.
Kodak, for instance, allows you to
download your original high-res images,
but many only display a low-quality preview
for you to check and place a reprint order.
Reprints are then made from higher-
resolution files. The best advantage of
having this service is that you can share a
password-protected page with friends
across the world and they can place an
order directly with the lab, without the
involvement of you or your cheque book!

Some services also offer a customised
proof preview, typically for wedding
photographs and will liaise with your client
for a small fee, leaving you to get on with
taking photographs.

Overseas labs

An international lab like Colormailer has
different servers in Europe, USA and
Australia. You can choose to upload to any
of these sites and take advantage of the
local postal service, saving you airmail costs
and dramatically reducing delivery times.

File extensions

For Mac users, a file extension is an
absolute must for uploading images, or
they will be rejected by the server.

Upload software

Most Internet labs work through the two
dominant browsers Internet Explorer and
Netscape Communicator and on both PC
and Mac platforms. Other labs use
specially designed stand-alone software,
like ColorMailer Photo Service 3.0. Freely
available through their website, this
small utility updates itself automatically
and puts more tools at your disposal
than either of the browsers.

Most useful is the print preview
function, shown below, which shows the
kind of borders your image will be
printed with. Simple cropping tools and
rotating tools are provided too. Unlike
most services, the ColorMailer software
tells you if you have ordered an
enlargement that exceeds the capability
of your image resolution.

Weblinks

www.photobox.co.uk

www.fotowire.com

www.photos@kodak.com

www.fotango.com

www.colorplaza.com

Profile suppliers

You can buy custom-made profiles to calibrate your own individual printer and profiles that convert your images for specific paper/printer combinations.

Custom-made profiles

ConeStudio in the USA offer one of the simplest custom-profile services. Start by downloading a test target image from their website, like the one shown above.

Configure your colour management and printer settings, following precise instructions and keep a detailed record of your settings for later.

Print off the test target on your favourite paper but be aware that the profile is only valid for one kind of paper/ink/printer chain. Post the print to ConeStudio and they will analyse the colours and generate a profile for your workstation.

http://www.inkjetmall.com

Buying off the shelf

If you don't trust your own colour judgement or if you are baffled by the seemingly infinite number of variables in the digital-printing process, then an off-the-shelf profile could be the answer to your problems.

ConeStudio sells over 1000 profiles for matching the most popular papers to an extensive range of inkjet printers both new and old. Like the custom-made service, described to the left, each profile is only appropriate for one combination of media, ink and printer, so you would be wise to decide on a favourite combination before committing. Another issue to consider, should you be concerned at the value of your purchase, is the future availability of your favourite products.

At a cost equivalent to a couple of packets of inkjet paper, a ConeStudio profile can be supplied on CD or by email.

http://www.inkjetmall.com

Free Lyson profiles

Go to the Lyson website to download free profiles for Lyson media and inksets for both Mac and PC workstations.

The site offers extensive instructions on how to install the profiles and how to configure Photoshop to take maximum advantage. The files are zipped and can only be unzipped using a compression utility like Stuffit Expander.

On the site there are lots of extra snippets of information including tips and background jargon busting, plus an extensive section on independent testing for estimated fading and lightfastness of most Lyson paper and inkset combinations.

If you have an older version of Photoshop, like v3.0 or v4.0, there's useful background help on establishing the right colour-management approach.

http://www.lyson.com

Equipment and suppliers

National newspaper adverts for computers deliver a smokescreen of numbers and jargon that make little sense to a non-computer user.

Hardware

ESSENTIAL KIT

For a new user: Apple iMac with 128Mb RAM, Umax Astra flatbed scanner, Epson Stylus Photo 890 A4 colour inkjet.
For an advanced user: Apple G4 computer with 256Mb RAM, Mitsubishi Diamond Pro Plus 19 monitor, Umax Astra flatbed scanner, Epson Photo Stylus 1290 A3 colour inkjet, CD Writer, Nikon 35mm film scanner.

Buying kit

Bundles can sometimes seem an ideal way to acquire a full complement of kit all in one go, but there are many pitfalls.

Unless all components of a system are recognisable and reputable brands, don't bother. Opt for flatbeds made by UMAX, Epson and Canon, good film scanners by Nikon, Canon and Minolta and printers by Epson.

Best prices can be found via Internet dealers and good savings can be made on refurbished kit or last season's stock.

Don't be attracted to buying the fastest computer, as even a lowly 300Mhz will be fast enough to cope with all your demands for desktop inkjet output. For a huge saving, you will only sacrifice a couple of seconds of processing time. A good plan is to read equipment reviews in professional photography magazines like the *BJP.*

Software

ESSENTIAL APPLICATIONS

Adobe Photoshop 6.0 comes at a high cost for a first-time user, but can be updated for about a quarter of the full price each time a new version is launched. With more tools and functions than you'll ever really use, you can customise Photoshop to suit your own working methods. For both Mac and Windows PC. Best prices via Internet dealers like **www.macwarehouse.co.uk** for UK citizens and .com for USA.

Adobe Photoshop Elements is a new and much lower-cost alternative to Photoshop 6.0. Aimed at the home user and amateur photographer, this application has many of the functions of v6.0 but lacks any colour-management tools. If you are just starting out and want to practise manipulation techniques rather than concentrate on print accuracy, this is a very good option for both Mac and Windows PC. This package can be found as a freebie in many bundle offers with digital cameras and scanners.

Jasc Paint Shop Pro is a Windows PC only application that is a best-seller in its price range. With tools and functions familiar to Photoshop users, including layers and levels, Paint Shop Pro is a good starting point if you have a basic home PC. Often bundled like Photoshop Elements.

Bookbinding

ESSENTIAL TOOLS

Bone folder, scalpel, Stanley knife, metal ruler, two mini G-clamps, darning needle, cutting mat and a solid work table.

MATERIALS

You can buy cover cloth, linen tapes, mull, strawboard and bookbinding PVA only from specialist suppliers such as:
Falkiner Fine Papers Ltd
76 Southampton Row
London WC1B 4AR
Tel: 020 7831 1151

FURTHER READING

The Thames and Hudson Manual of Bookbinding by Arthur W. Johnson, ISBN 0-500-68011-6.

Software resources

In addition to your standard imaging application, there are many useful plug-in and shareware software tools that will customise your workstation.

Extensis PhotoFrame

Made by a subsidiary company of Adobe, Extensis PhotoFrame is a comprehensive tool for adding creative edge and border effects to your images.

Available as a Photoshop plug-in, it appears as a drop-down menu item in your application after installation. With over 1000 custom-made edges including watercolours, masks and film edges, each one can be resized, transformed, coloured and blended to fit your image.

The Photoframe dialogue box displays your image with a range of tools, and once committed, the effect remains as a separate layer, for you to remove or adjust later on.

It's moderately priced and available for both Mac and PC platforms. There's a free 30-day trial for download from the Extensis website, using only a fraction of the frames available in the full product.

http://www.extensis.com

PhotoFrame Online

A free variation on the full Photoframe product is Photoframe online. This web-based application works through your browser: after downloading a clever browser plug-in, you can apply a range of edge effects to your images.

There's no uploading your images to a remote server, but you do need to maintain your online status. All the work happens client-side, i.e. on your machine, so you are not limited to working on compressed or small size files.

Useful if you are working on a computer which does not have your familiar software, Photoframe Online can only process JPEG and TIFF format images.

Full instructions are supplied on the Creativepro site, but you do have to register as a user (cost-free) before downloading. Click on the Services link from the home page.

http://www.creativepro.com

Drivers and updates

The compatibility between your software and peripherals will change as you build up your workstation. However, hardware manufacturers also update their drivers to work with products released later.

You don't need to buy these updates and many are supplied freely on the manufacturer's site. An easier way of finding drivers and plug-ins is to use a shareware portal like Download.com. Supporting all platforms, Download provides a comprehensive resource for searching and downloading useful software.

The only cost is the length of time it takes to download the application, but with broadband and ADSL Internet links, this is less of an issue nowadays.

Download also features many useful trial applications of professional products such as Adobe Photoshop.

http://download.cnet.com

Learn more at Photocollege

For additional tips, step-by-steps and techniques not featured in this book, visit the author's own website at www.photocollege.co.uk

Step-by-steps

Photocollege is a free web learning environment, set up to make conventional and digital photography more fun. With features, galleries and a bookshop, all the information is presented in an easy-to-read format.

In the Photoshop section, there are several step-by-step projects taking you through simple edge effects without the need for plug-ins, including drop-shadow edges, mountboard edges and bevels.

To use this section, keep your browser open at the same time as your imaging application and read the instructions alongside your project work.

Making a link between familiar darkroom techniques and Photoshop, these projects will help you bridge the gap.

Most projects can be completed in under ten minutes and gather together a range of useful techniques to take your creative image processing further.

Download Photoshop resources

Most complex Photoshop adjustments and processes can be saved and stored ready to replay on other images. These files can also be exchanged with other users over the Internet.

At the Photocollege website there are lots of Photoshop resources for download, including the RingAround colour correction chart for both v5.5 and v6.0 users.

Channel mixer recipe files, recipes for digital lith and specially formulated duotone colour recipes are included for download for both Mac and PC users in a zipped format.

Useful action files and droplets, which turn a string of creative or technical processes into a self-running automated sequence (like a macro) can be contributed to the site by email.

If you want to share your hard-won discoveries with other keen users, send it to me and I'll post it on the site: timdaly@photocollege.co.uk

Study

Photocollege is aimed at professionals and student photographers who are keen to learn more about digital and conventional photography online.

The Photoshop for Photographers section includes lots of features looking at the 'nuts and bolts' of digital photography like contrast correction, managing data and printing out. The Study Centre offers tips on conventional shooting and darkroom techniques too.

If you've got only a little computer knowledge, then this is a good place to start.

Earn a qualification

If you want to put your skills and knowledge to the test and gain an internationally recognised qualification, you can study a wide range of conventional and digital photography courses at Photocollege in the freedom of your own home and in your own time.

Cataloguing your images

To keep track of your images is no easy thing if you are burning CD volumes and storing images on a range of removable media. A useful software addition is Extensis Portfolio.

If you're in the habit of working on a creative project without keeping tabs on your images' final resting place, image retrieval can be time consuming as well as frustrating.

A purpose-made image database product like Extensis Portfolio lets you catalogue and manage your image files, even if they reside on external disks or volumes.

Catalogues can be made for any subject matter or topic by simply dragging the folder or directory icon over a new catalogue window, and the software takes care of naming, recording and making thumbnails.

Once finished, the catalogue file can be saved on your hard drive and images still previewed even if your disks have been unmounted or removed. As the catalogue file keeps tiny previews of your images, it's a much more efficient way to keep track without having to store all your volumes on the hard drive.

The success of any catalogue or database relies totally on the accuracy of the data input at the start, but for each image held in the database you can enter your own specific shooting details.

Keywords can be entered too, so you can search your collection for images which conform to a subject matter or location, or any other criteria you choose to create. Once built, you can use the powerful search function.

Above is a catalogue for one shoot, showing all the saved images with their filenames underneath. Portfolio uses an automated process to convert your high-res originals into thumbnail-sized previews, making a record of file size and format, creation date and file location at the same time.

Double clicking on each thumbnail will bring up a full-sized version of the image, right, if the original disk is mounted. Both file size and pixel dimensions are shown in the image window.

The best function of the application is that you don't need to have high-end imaging software like Photoshop to run it, so it can be located on a laptop or other secondary workstation.

Further details found at:

http://www.extensis.com

Storage and presentation

Keeping your digital prints in tip-top condition means following the same storage precautions used for photographic materials.

Storage products

Since both photographic and artist's prints have become seriously collectable items, a great deal of research has been done to improve their safe and stable keeping.

Digital-printing technology is still in its infancy, but many contemporary prints will end up in national museum collections of the future.

In order to extend the lifespan of your work, you will need to ensure that it's stored properly and, when exhibited, mounted in a safe and reversible manner.

There are many clear plastic sleeves and similar products used to protect artwork inside portfolios, but only the best quality will give true archival protection.

Super high-gloss polyacetate sleeves are only available from specialist photographic suppliers like Silverprint in the UK, but their construction of an inert compound means no chemical agents are transferred to the all important artwork. All major sizes and even custom shapes can be ordered to fit your work. Used in the all major museums to safeguard paper-based artwork, these kinds of sleeves also protect against the damaging effects of grease from fingers and hands.

The best feature of this material is its very high clarity, resulting in the highest possible transparency, leaving you and others to enjoy your work to the full.

Mounting

For exhibition display, the safest and most practical way to show your work is within a hinged window mount made from acid-free mount board. Made from two identical sized boards, one with a cut window aperture and the other a solid back, the window mount will hold your print in place without the need for adhesives. Shown below is the ideal way to prepare a window mount:

Using an angled mount blade, the aperture for the image is cut in the top board before it is taped to the bottom board. The print is held in place by archival fixings, without the need for any adhesives or tapes. Once the hinged mount is closed over the print, little or no print movement occurs.

Archival fixings

To attach prints firmly into window mounts or any other supporting mount, a device must be chemically inert, free from corrosive adhesives and, most importantly, allow the natural expansion of the print.

All paper media expands and contracts in response to changing environmental humidity, even when encased in glass-fronted frames. Prints that are taped along the edges to backing boards with cheap and cheerful masking tape will in time stretch and buckle in response to climate change.

A much better system is to use large acetate photo corners, found in most stationers. These are used inside a window mount, as shown to the left, to keep the print in exactly the right position. Without attaching any adhesives to the print surface, the humble photo corner will allow the print to expand and contract safely.

For larger-scale prints not window mounted, including those with decorative deckled edges, invisible mounting can be made with acid-free linen hinging tape, as made by Lineco Inc. This material is made with an acid-free carbohydrate and protein adhesive, which is water-soluble.

Once the exhibit is ready to return to safe storage, a little water is dabbed onto the tape from behind, which loosens away from the artwork without damaging it.

Jargon buster

Artifacts
By-products of digital processing, like noise, which degrade image quality.

Aliasing
Square pixels describe curved shapes badly and close-up look jaggy. Anti-aliasing filters and software lessen the effects of this process by reducing contrast at the edges.

Background printing
A way of letting an image document print while still retaining the ability to work in the current application.

Batch processing
Using a special type of macro or Action file, batch processing applies a sequence of preset commands to a folder of images automatically.

Bit
A bit is the smallest unit of data representing on or off, 0 or 1, or black or white.

Bit depth
Also referred to as colour depth, this describes the size of colour palette used to create a digital image, e.g. 24-bit.

Bitmap image mode
Bitmap image mode can display only two colours, black and white, and is the best mode to save line art scans. Bitmap images have a tiny file size.

Bitmap Image
A bitmap is another term for a pixel-based image arranged in a chessboard-like grid.

Byte
Eight bits make a byte in binary numbering. A single byte can describe 0–255 states, colours or tones.

Card reader
Digital cameras are sold with a connecting cable that fits into your computer. A card reader is an additional unit with a slot to accept camera memory cards for faster computer transfer.

CCD
Charged Coupled Device is the light-sensitive 'eye' of a scanner and 'film' in a digital camera.

CDR
Compact disk recordables store digital data and are burned in a CD writer. With a capacity of 640Mb, CDRs are a very low-cost way to store digital images.

CDRW
Compact disk rewriteables can be used many times, unlike CDRs which can only be burned once.

CIS
Contact Image Sensor is a recent alternative to CCD in scanning technology, giving higher resolution values but using different measuring criteria.

Clipping
Clipping occurs when image tone close to highlight and shadow is converted to pure white and black during scanning. Loss of detail will occur.

CMYK image mode
Cyan, Magenta, Yellow and Black (called K to prevent confusion with Blue) is an image mode used for litho reproduction. All magazines are printed with CMYK inks.

Colour Space
RGB, CMYK and LAB are all kinds of different colour spaces with their own unique characteristics and limitations.

Compression
Crunching digital data in smaller files is known as compression. Without physically reducing the pixel dimensions of an image, compression routines devise compromise colour recipes for groups of pixels, rather than individual ones.

CPU
The Central Processing unit is the engine of a computer, driving the long and complex calculations when images are modified.

Curves
Curves is a versatile tool for adjusting contrast, colour and brightness by pulling or pushing the line.

CRT
A cathode ray tube is the light-producing part of a monitor.

Descreening
The removal of a halftone pattern from a lithographic image during scanning. This avoids a moire effect when output.

Diffusion dithering
A dithering technique allocates randomly arranged ink droplets, rather than a grid, to create an illusion of continuous colour.

Dithering

A method of simulating complex colours or tones of grey using few colour ingredients. Close together, dots of ink can give the illusion of new colour.

DIMM

Dual Inline Memory Modules are a kind of RAM chip, sold with different capacities, e.g. 128Mb, and with different speeds.

Digital Zoom

Instead of pulling your subject closer, a small patch of pixels is enlarged or interpolated to make detail look bigger than it really was.

Dropper tools

Pipette-like icons that allow the user to define tonal limits like highlight and shadows by directly clicking on image areas.

Dye sublimation

A kind of digital printer that uses a CMYK pigment-impregnated donor ribbon to pass colour onto special receiving paper.

Dot pitch

A measure of the fineness of a CRT monitor's shadow mask. The smaller the value, the sharper the display.

DPI (scanner)

Dots per inch is a measure of the resolution of a scanner. The higher this number is, the more data you can capture.

DPI (printer)

Printer DPI is an indication of the number of separate ink droplets deposited by a printer. The higher the number, the more photo-real results will look.

Duotone

A duotone image is constructed from two different colour channels chosen from the colour picker and can be used to apply a tone to an image.

Driver

A small software application that instructs a computer how to operate an external peripheral like a printer or scanner. Drivers are frequently updated but are usually available for free download from the manufacturer's website.

Dynamic range

A measure of the brightness range in photographic materials and digital sensing devices. The higher the number, the greater the range.

EPS

Encapsulated Postscript is a standard format for an image or whole page layout, allowing it to be used in a range of applications.

File extension

The three or four letter/number code that appears at the end of a document name, preceded by a full stop, e.g. landscape.tif. Extensions enable applications to identify file formats and enable cross-platform file transfer.

FireWire

A fast data transfer system used on recent computers, especially for digital video and high-resolution image files. Also known as IEEE1394.

Gamma

The contrast of the midtone areas in a digital image.

Gamut

A description of the extent of a colour palette used for the creation, display or output of a digital image.

GIF

Graphics Interchange Format is a low-grade image file for monitor and network use, with a small file size due to a reduced palette of 256 colours or less.

Grayscale

Grayscale mode is used to save black and white images. There are 256 steps from black to white in a grayscale image, just enough to prevent banding appearing to the human eye.

Halftone

An image constructed from a dot screen of different sizes to simulate continuous tone or colour. Used in magazine and newspaper publishing.

Highlight

The brightest part of an image, represented by 255 on the 0–255 scale.

Histogram

A graph that displays the range of tones present in a digital image as a series of vertical columns.

ICC

The International Colour Consortium was founded by the major manufacturers in order to develop colour standards and cross-platform systems.

Inkjet

An output device which sprays ink droplets of varying size onto a wide range of media.

ISO Speed

Photographic film and digital sensors are graded by their sensitivity to light. This is sometimes called film speed or ISO speed.

Interpolation

Enlarging a digital image by adding new pixels between existing ones.

Jaggies

See Aliasing.

JPEG

A lossy compression routine used to reduce large data files for easier transportation or storage. Leads to a reduction in image quality.

Kilobyte (K or Kb)

1024 bytes of digital information

Lab image mode

A theoretical colour space, i.e. not employed by any hardware device, used for processing images.

Layered image

A kind of image file, such as the Photoshop file, where separate image elements can be arranged above and below each other, like a stack of cards.

Layer blending

A function of Photoshop layers, allowing a user to merge adjoining layers based on transparency, colour and a wide range of non-photographic effects.

Layer opacity

The visible 'strength' of a Photoshop layer can be modified on a 0–100% scale. As this value drops, the layer merges into the underlying.

Levels

A common set of tools for controlling image brightness found in Adobe Photoshop and many other imaging applications. Levels can be used for setting highlight and shadow points.

Line art

A type of original artwork in one colour only such as typescript or pencil drawings

Megapixel

Megapixel is a measurement of how many pixels a digital camera can make. A bitmap image measuring 1800 x 1200 pixels contains 2.1 million pixels (1800 x 1200=2.1 million), made by a 2.1 Megapixel camera.

Megabyte (Mb)

1024 kilobytes of digital information. Most digital images are measured in Mb.

Noise

Like grain in traditional photographic film, noise is an inevitable by-product of shooting with a high ISO setting. If too little light passes onto the CCD sensor, brightly coloured pixels are made by mistake in the shadow areas.

Optical resolution

Also called true resolution, this is a measure of the hardware capability, excluding any enhancements made by software trickery or interpolation and is usually found in the small print!

Parallel

A type of connection mainly associated with printers and some scanners. The data-transfer rate of a parallel connection is slower than SCSI or USB.

Pantone

The Pantone colour library is an internationally established system for describing colour with pin-number-like codes. Used in the lithographic printing industry for mixing colour by the weights of ink.

Path

A path is a vector-based outline used in Photoshop for creating precise cut-outs. As no pixel data is involved, paths add a tiny amount to the file size and can be converted into selections.

PCI Slot

A Peripheral Component Interface Slot is an expansion bay in a computer used for upgrading or adding extra connecting ports or performance-enhancing cards.

Peripherals

Peripherals, like scanners, printers, CD writers etc, are items used to build up a computer workstation.

Pictrography

A type of high-resolution digital printer, made by Fuji, that images directly onto special donor paper without the need for processing chemistry.

Pigment inks

A more lightfast inkset for inkjet printers, usually with a smaller colour gamut than dye-based inksets. Used for producing prints for sale.

Pixel

Taken from the words Picture Element, a pixel is the building block of a digital image, like a single tile in a mosaic. Pixels are generally square in shape.

Profile
The colour-reproduction characteristics of an input or output device. This is used by colour-management software such as ColorSync to maintain colour accuracy when moving images across computers and input/output devices.

Quadtone
A quadtone image is constructed from four different colour channels, chosen from the colour picker or custom colour libraries like Pantone.

RAM
Random Access Memory is the part of a computer that holds your data during work in progress. Computers with little RAM will process images slowly as data is written to the hard drive, which is slower to respond.

RIP
A Raster Image Processor translates vector graphics and fonts into bitmaps for digital output. RIPS can be both hardware and software.

Resolution
The term resolution is used to describe several overlapping things. In general, high-resolution images are used for printing out and have millions of pixels made from a palette of millions of colours. Low-resolution images have fewer pixels and are only suitable for computer monitor display.

RGB image mode
Red, Green and Blue mode is used for colour images. Each separate colour has its own channel of 256 steps and pixel colour is derived from a mixture of these three ingredients.

Selection
A fenced-off area created in an imaging application like Photoshop which limits the effects of processing or manipulation.

SCSI
Small Computer Systems Interface is a type of connector used to attach scanners and other peripherals to your computer.

Scratch disk
A portion of a computer's free hard disk (or an external drive) that acts as overflow RAM during work in progress.

Shadow
The darkest part of an image, represented by 0 on the 0–255 scale.

Shadow mask
A type of finely perforated stencil that creates pixels on a CRT monitor.

Sharpening
A processing filter which increases contrast between pixels to give the impression of greater image sharpness.

Unsharp Mask (USM)
This is the most sophisticated sharpening filter, found in many applications.

USB
Universal Serial Bus is a recent type of connector which allows easier set-up of peripheral devices.

TIFF
Tagged Image File Format is the most common cross-platform image type used in the industry. A compressed variation exists which is less compatible with DTP applications.

Tritone
A tritone image is constructed from three different colour channels, chosen from the colour picker or custom colour libraries like Pantone.

TWAIN
Toolkit Without An Interesting Name is a universal software standard which lets you acquire images from scanners and digital cameras from within your graphics application.

White balance
Digital cameras and camcorders have a white-balance control to prevent unwanted colour casts. Unlike photographic colour film, which is adversely affected by fluorescent and domestic lights, digital cameras can create colour-corrected pixels without using special filters.

White Out
In digital images, excessive light or overexposure causes white out. Unlike film, where detail can be coaxed out of overexposed negatives with careful printing, white pixels can never be modified to produce latent detail.

VRAM
Video RAM is responsible for the speed, colour depth and resolution of a computer monitor display. A separate card can be purchased to upgrade older machines with limited VRAM.

Index

Credits

Graphic design
Nina Esmund
nina@photocollege.co.uk

Images
All photographic and illustrative images
are copyright the author except:
page 10: courtesy of Apple Computers
page 15: courtesy of Epson UK
page 16: courtesy of Fuji Uk
page 22: courtesy of Umax (top) and
Canon UK (bottom)
page 26: courtesy of Olympus
page 42: courtesy of Phillip Andrews
(bottom)
page 43: courtesy of Lyson UK (top) and
Canon UK (bottom)
page 142: courtesy of Somerset (Inveresk
PLC)
page 146: courtesy of ConeStudios

Software
The author would like to thank the
following for their help in providing
evaluation software for this book: Adobe,
Extensis and ConeTech at Inkjetmall.com

Hardware
Thanks to Epson for their continuing
support.

Materials
Thanks to Cathy Frood at Somerset and
Marrutt Digital for Lyson media support.

Thanks to:
Chris Dickie at AG Darkroom Practice and
Photography for his continuing
encouragement and patience.

Eddie Ephraums at Argentum for his help and
support.

Phillip Andrews for sound advice on all
complicated issues.

Will Cheung at Practical Photography and
Digital Photo.

Paul Duke and Dominic Wiliams and the
photography department at RSAD/East
Surrey College.

Further Reading
Tim Daly writes regular features on digital
techniques for *AG Darkroom Practice and
Photography*
Quarterly by subscription only from
Timothy Benn Publishing
39 Earlham St, Covent Garden, London
WC2H 9LD.
tel: 020 7306 7140
email: subs@benn.co.uk